To mum

Well maybe one day
I'll be signing one
of your books!

Lots of love
and
best wishes for 1990!

Isabelle
X X X.

ARTISTS in CAMERA

A GALLERY OF STAR PORTRAITS BY PHOTOGRAPHER ROY JONES

Introduction by Sir Alec Guinness

Text by Michael Owen

Action Research for Multiple Sclerosis
will receive a royalty for the sale of this book.

PRION

This book was devised by The Marketing Office
and produced by Multimedia Books Limited

Copyright © Multimedia Books Limited

Editor: Linda Osband
Design: Adrian Gray for Art Attack Studios
Production: Zivia Desai

First published in the United Kingdom in 1989 by
PRION
An imprint of Multimedia Books Limited
32-34 Gordon House Road
London NW5 1LP

ISBN 1 85375 036 0

Typesetting: Pressdata, London
Artwork: Art Attack Studios, London
Film Origination: Reprocraft 1987 Ltd, London
Printed in Hong Kong by Imago Publishing Ltd

*This book is dedicated to the memory of
Sydney Edwards.*

*With thanks to all those who have made this book possible,
especially Lynne Burton, Jose Phillips and Arnon Orbach.*

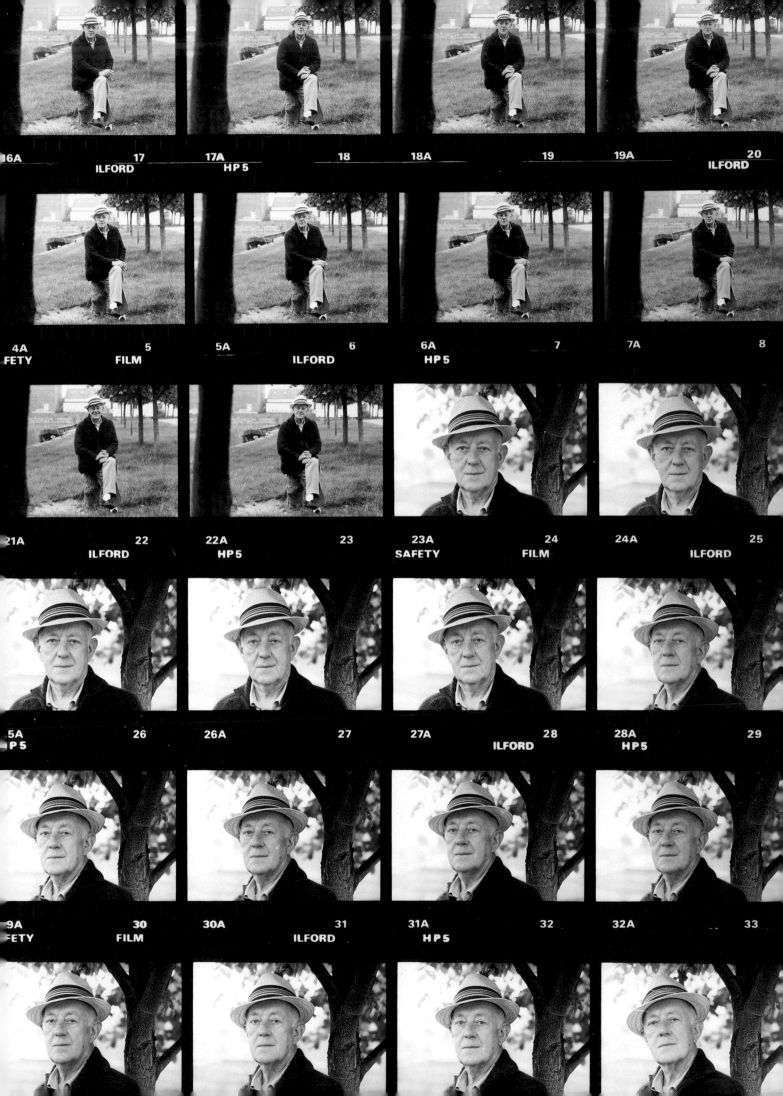

INTRODUCTION

Some twenty-odd years ago in Hollywood, I remember Merle Oberon glancing in a mirror and saying, 'Mine is the last of the great faces.' Merle was undoubtedly a beautiful enchantress, but she was wrong. A younger generation has produced some superb faces and so will the future.

The book is not confined to performers, but includes celebrities from other fields. A 'great face' is not necessarily a beauty – often far from it – and what struck me forcibly when looking at these photographs was how wonderfully lived-in so many of the faces are. They appear to have given of themselves to the world and that has left its mark, whether of joy or suffering; and those who are no longer with us not only revive memories but seem to breathe again.

I doubt if there are many public personalities who enjoy being photographed. Most sitters cringe with self-consciousness, subjected as they so often are to complicated, agonizing instructions. However, I am sure that Roy Jones's naturalness and self-effacement put all at their ease, which is apparent in the photographs that follow.

Michael Owen has a touching little story in the book, tucked away among many amusing anecdotes and sharp comment, of Jack Lemmon being casually photographed by Roy. It has the ring of absolute truth. I leave you to discover it.

Alec Guinness

THE UNTOLD STORY

That fine actress Felicity Kendal got it right when she opened an exhibition of Roy Jones's photographs at the National Theatre in London. She told the assembled crowd of fellow actors and newspaper people: 'There are three pleasures in opening a play in the West End. The first is being asked, the second is the rehearsals and the third is knowing you will be photographed by Roy.' Then she added, rather cheekily: 'As far as I'm concerned Michael Owen is just the bloke who turns up with him.'

She spoke for her profession as the leaders of the London arts world know that when Roy turns up they will be photographed unfussily, without gimmick, in the most relaxed circumstances and to the very best result.

Every picture tells a story and frequently there is a story behind the picture which does not always get told. Some are recalled in the following pages of this book, but some are not – like the occasion when we went to meet a distinctly disgruntled Lee Marvin, who by mid-morning already had three fingers of Scotch in his glass.

The atmosphere was tense going on hostile when Marvin muttered something Roy took to be a joke and laughed somewhat too loudly. Marvin took insult, jumped to his feet and glowered threateningly: 'What the hell's that guy laughing at?' We calmed him down, then Roy discovered that he had left the lens he needed back at the office. I had to sustain the interview with an increasingly impatient actor for an hour until he returned. The photographs were achieved in record time and we made a speedy departure.

Jack Nicholson provided a surprise when his first appointment on arrival in London from Tokyo was an interview with us. Jet-lagged to the eyeballs, he said: 'Sorry fellahs, I've had it. Give me a five-minute nap and I'll be

right with you.' In jeans and heavy leather boots, he stretched out on the hotel sofa and promptly fell asleep. We waited in silence and then in less silence as we obliquely sought to wake him, but no amount of polite coughing was going to stir the by now snoring actor. After half an hour he suddenly jumped to his feet, grinned, said 'Thanks guys', and strode out of the room. No interview or photograph had taken place.

Visiting American stars understandably are frequently unaware of Roy's reputation and of the quality of his work and occasionally are less cooperative than they might be. Jack Lemmon was in that sort of mood after a particularly long press conference when Roy wanted a few minutes with the actor on the street to take a different picture from the one his fellow photographers had been taking inside. Mr Lemmon was patently not keen. Then he shot a second, searching look at Roy, put his hand on his shoulder and said: 'I hope you don't mind me asking, but do you have multiple sclerosis?' Lemmon had sensed something only one in a million would spot and, when the fact was confirmed, gave Roy his undivided attention for as long as he wanted. He then revealed that a close member of his family also had MS.

As this book will benefit Action Research for Multiple Sclerosis, I would just like to mention the way Roy came to terms when he was diagnosed as having MS. He changed his life overnight and adopted a new discipline with a strength of will and courage which . . . well, if I wore a hat I'd take it off to him.

This book is an overdue, permanent record of just some of the many outstanding photographs he has taken over the last two decades and I look forward to the many more to come.

Michael Owen

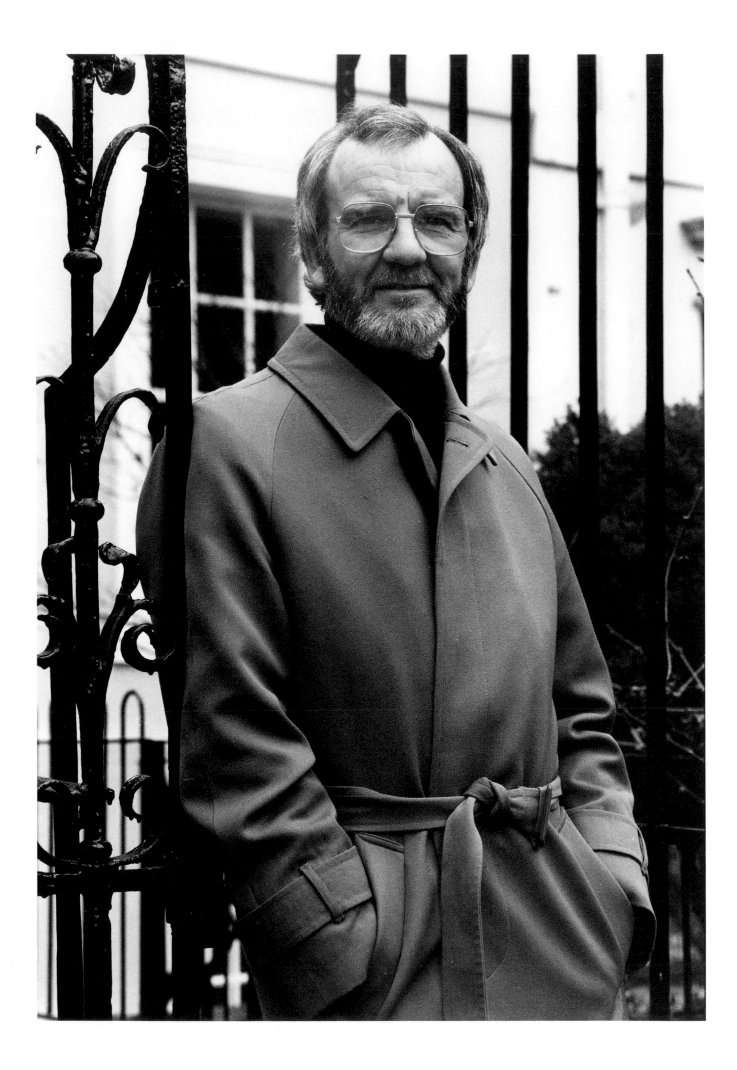

ROY JONES

Born in 1941, Roy Jones was brought up in the London borough of Islington. When he left school at fifteen, he looked for a career which would provide something beyond the conventional and his gaze fell on the newspaper world of Fleet Street. Without having previously held a camera, he joined the picture agency Central Press Photos at the most junior level and learned his craft covering all manner of news and sports stories.

He joined the *Evening Standard* as a news photographer at twenty-six and after a year was appointed arts and fashion photographer. He was in at the birth of a new kind of arts page, under the then arts editor Sydney Edwards, which expressed serious content through popular style with prominent photographic display as an essential ingredient. His portraits appearing on the centre pages every Friday became an admired feature of the paper, which continued when the column was retitled 'Friday People' under the current arts editor Michael Owen.

In the past twenty years he has met and photographed just about every leading personality in the performing arts and has travelled the world from China to the United States and from Australia to Russia.

In 1981 he was diagnosed as having multiple sclerosis. He abandoned fashion photography and concentrated exclusively on the arts. In 1988 his work was the subject of a major exhibition in the Olivier foyers of the National Theatre in London.

FRED ASTAIRE

Fred Astaire was the perfectionist, the ultimate song-and-dance man who took his seemingly effortless elegance across all the media from vaudeville, revue and musical comedy to the big and small screens. Yet the man from Omaha, Nebraska, who grudgingly followed his sister to a dance school as a boy, was endlessly self-deprecating about his art. Asked about his status as an acknowledged natural genius, he replied: 'I was just doing my job.' Inquire about the inspiration for that dancing dexterity and he says: 'I just put my feet in the air and move them around.' And then smiles shyly

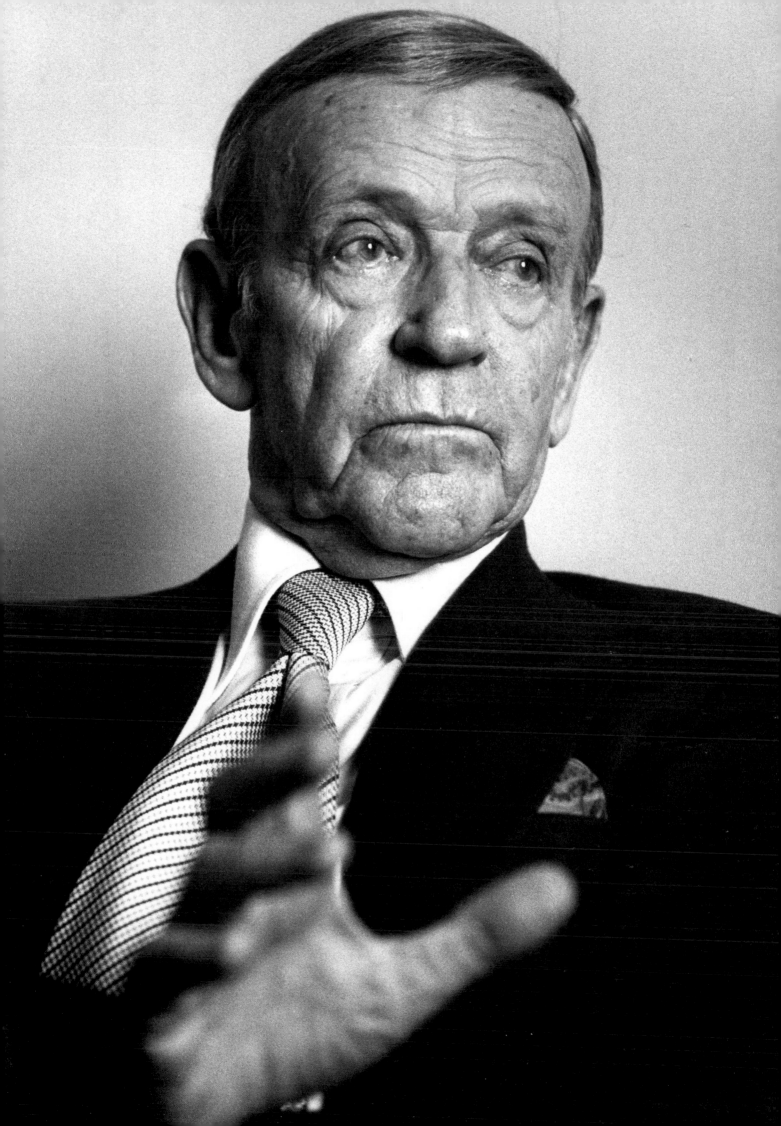

W. H. AUDEN

It was only in the later stages of his life, when that lined and pouched face had settled into the conformity of a damaged bun, that Wystan Hugh Auden was recognized as the most important English poet of his generation. His reputation had previously been clouded not just by the lack of appreciation of some of his contemporaries but also by his strong political beliefs, which took him to be an ambulance driver during the Spanish Civil War, his decision to emigrate to the United States at the outbreak of war in 1939 to become an American citizen and his association with the spy circles of Burgess and Maclean. Through it all he remained shy, private and ever watchful from behind that extraordinary mask of a face.

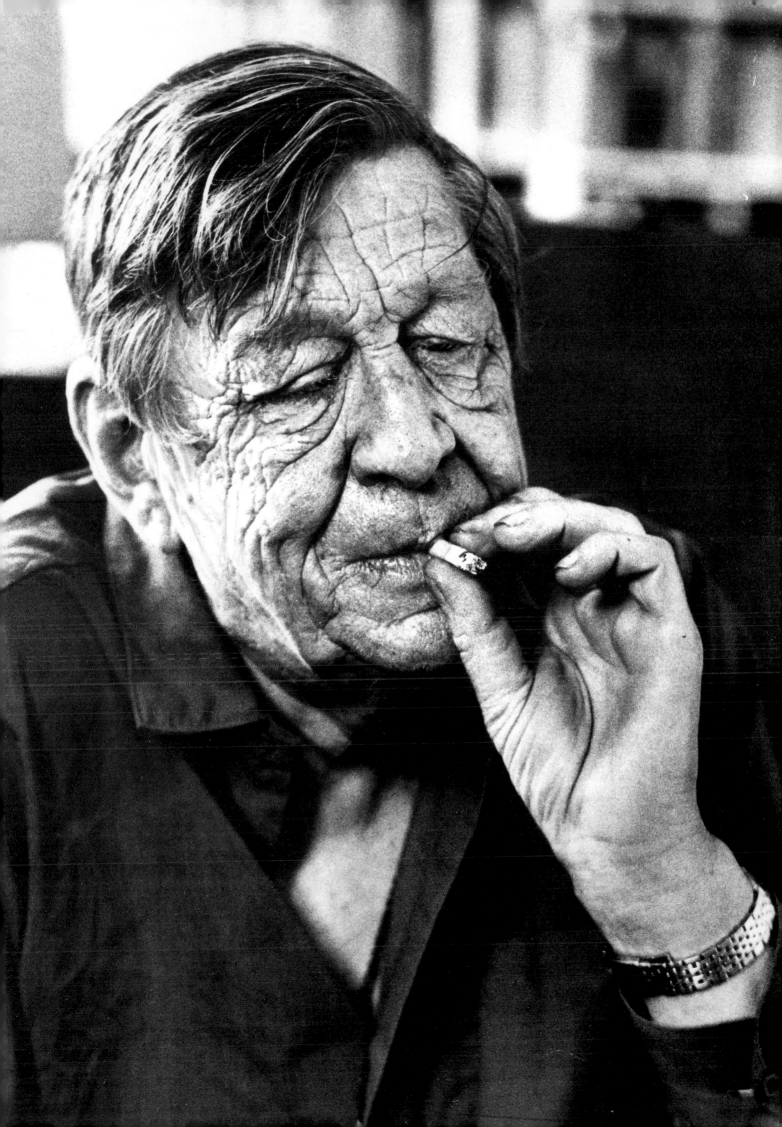

ALAN AYCKBOURN

Alan Ayckbourn looks more like a benign school-teacher or avuncular scoutmaster than the man who has been described as the greatest single force in English drama since Shakespeare. Before his fiftieth birthday he had written thirty-four plays - the later of which then drew comparisons with Chekhov for their innate intermingling of comic/tragic forces - and was directing productions ranging from Arthur Miller to pre-war British farce. How do you do it, Alan? 'Well, I do like to keep busy and as long as the ideas are there you might as well go with them. But I have not had a holiday recently and I'm beginning to think about one now.' Ayckbourn disappeared to the Caribbean briefly, but was back within a fortnight at his Scarborough theatre base plunging into a new bout of activity.

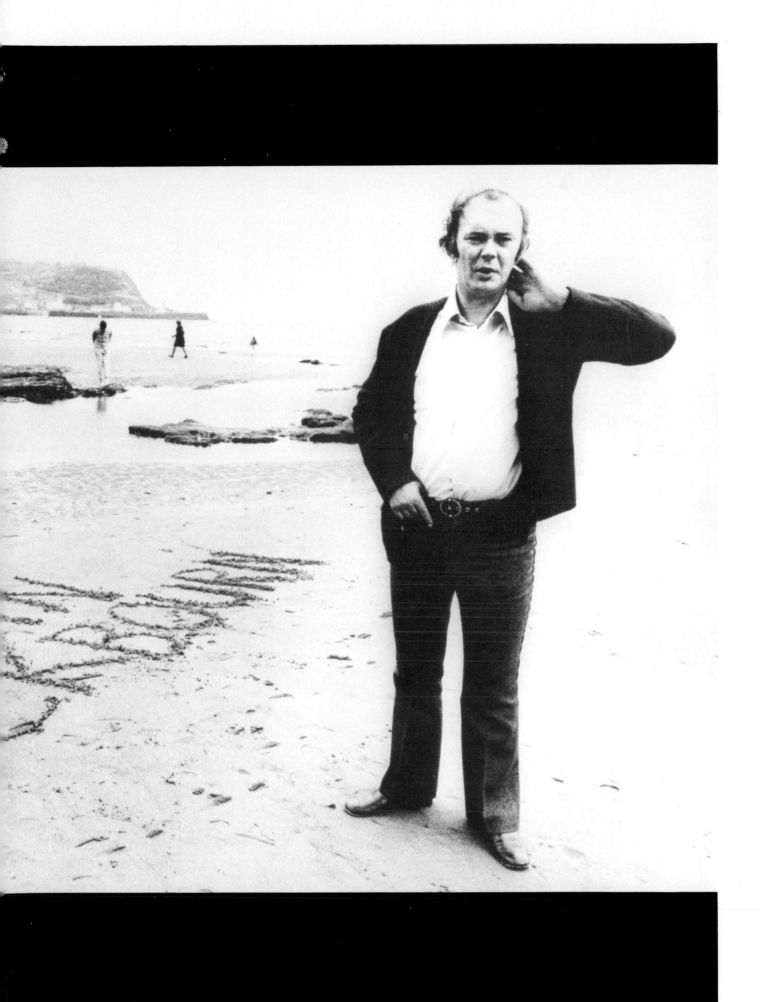

LAUREN BACALL

The green, lynx eyes dictate that this is a lady not to be messed with, the voice comes from the back of the throat and the laughter from somewhere deeper inside her. This is Bogie's girl of the movie era, who then married Jason Robards, went on to musicals, but waited until she got to London for her first classic play when - bravely - she appeared as an ageing, fading actress in Tennessee Williams's Sweet Bird of Youth *directed by Harold Pinter. She wanted to prove a point. 'What angers and frustrates me is when I am put in this category of being a personality and a star. That is not what I am in this profession for. I am a good actress, perhaps not a great one but great is a much misused word, but I am an actress. That's what I'm here to show.'*

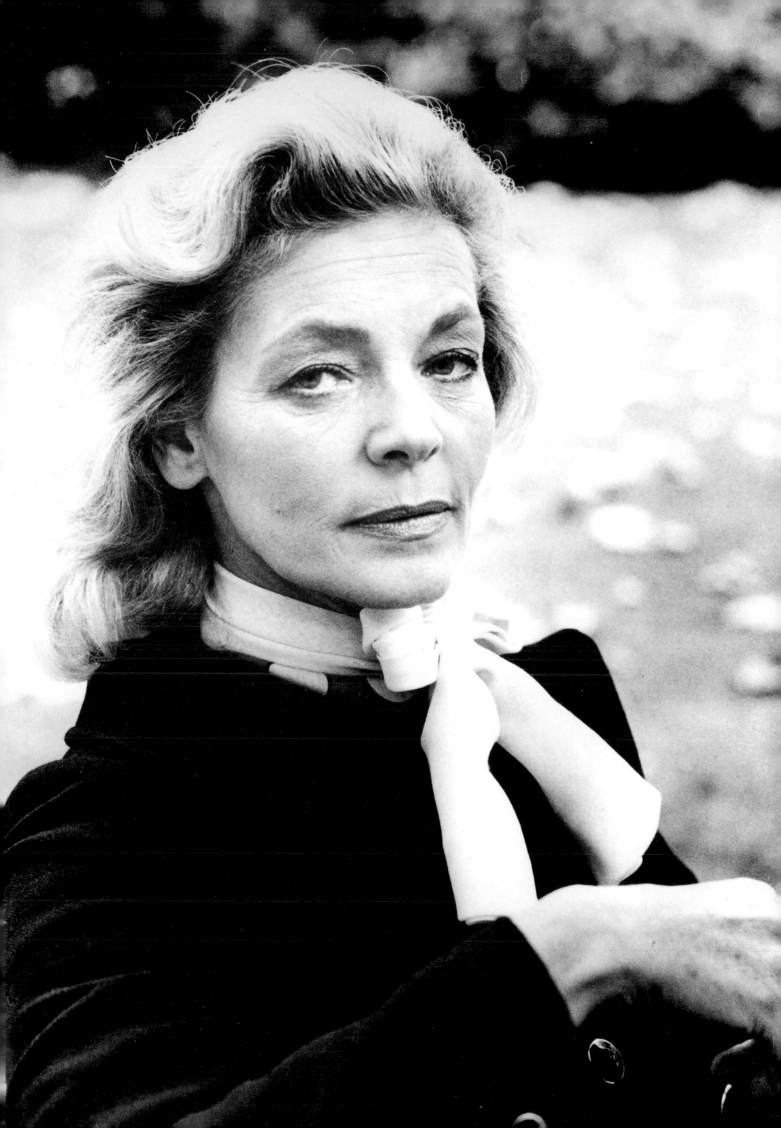

DAME JANET BAKER

In the ornamental gardens of a fairly grand suburban house near London the only sound was of birdsong. Inside, Dame Janet Baker finished a sentence with the words, '. . . and that will be my last performance.' It was the day she went public on her decision to quit the opera world. 'I want to be one of the people who will, I hope, withdraw in a dignified way earlier rather than later.' Dame Janet went on to continue her concert career, but as far as opera was concerned her decision was final.

'I look on my career as a debt to be repaid to God who gave me my voice rather than an ego trip. The fame? It never meant much to me. There are trappings in my life now I would gladly go without.'

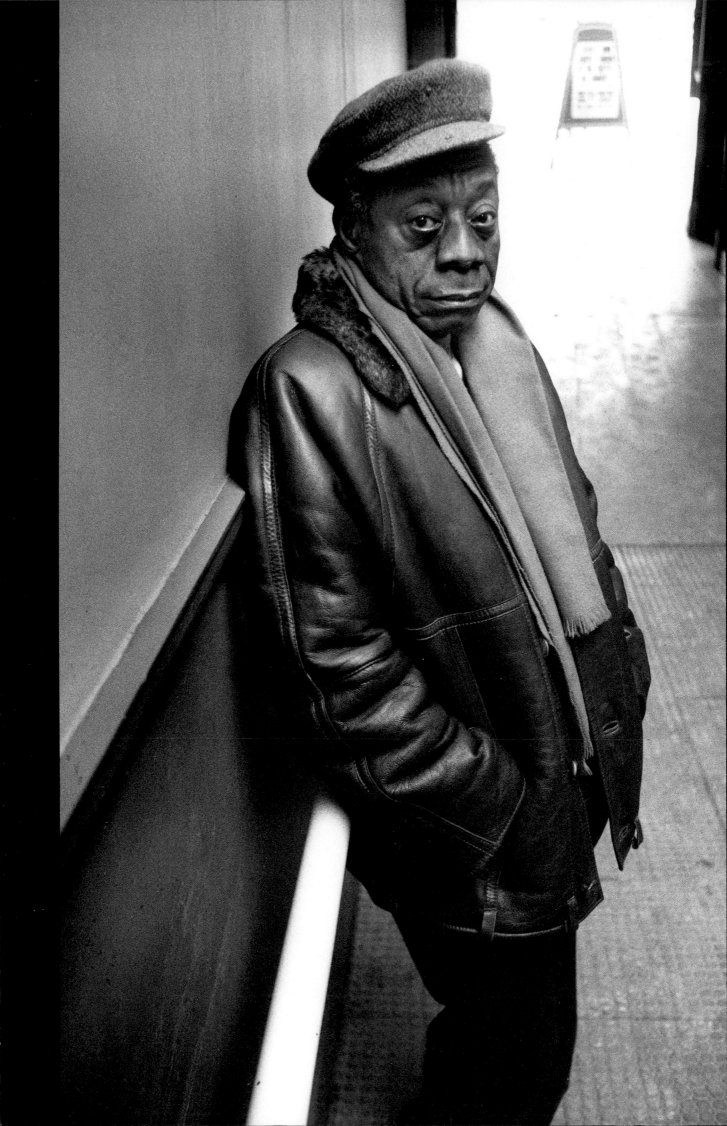

JAMES BALDWIN

The wise eyes of James Baldwin were still watchful of events around him as he nursed a whisky to discharge the jet-lag he had just brought from New York. He was in the unfashionable Kilburn quarter of London to see his first play, Amen Corner, *into a revival in a Fringe theatre which would later go on to the West End. The author of* Go Tell It to the Mountain, Giovanni's Room *and other novels described how he wrote his first play when he was virtually down and out in Paris. 'I was staying in an awful pension, but at least you got fed every night. When it was time to go home I had my air ticket, but I couldn't pay the bill. I was bailed out by Marlon (Brando). We've been friends ever since.'*

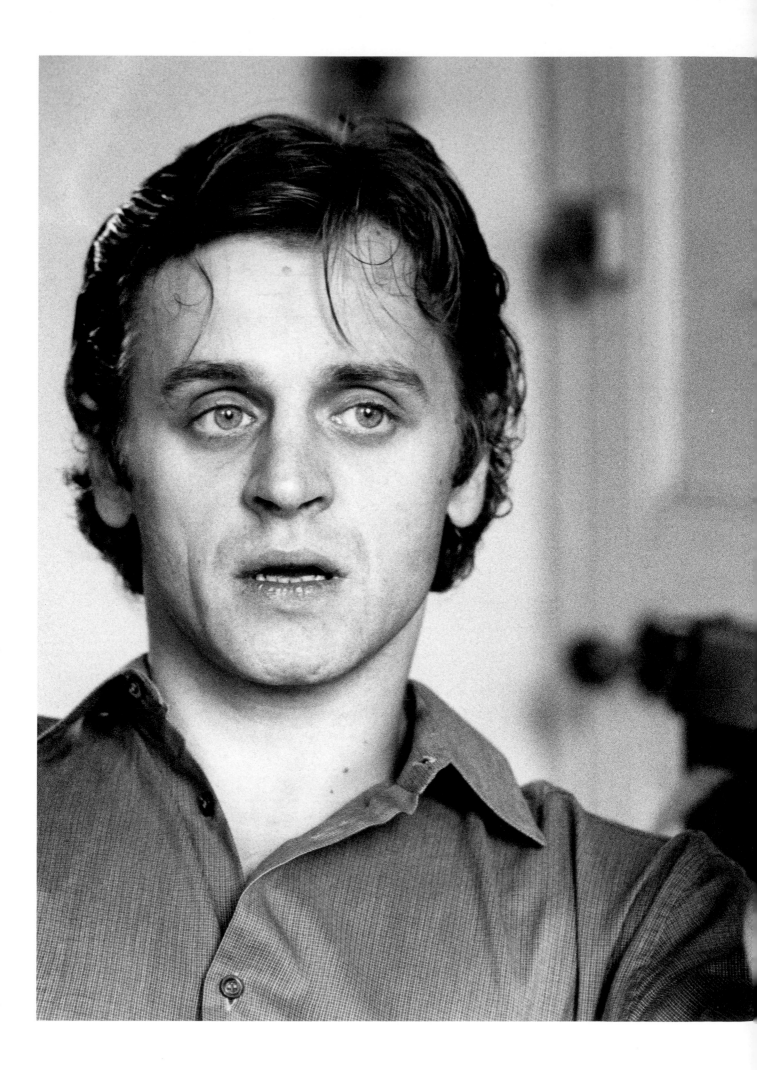

MIKHAIL BARYSHNIKOV

Universally known as Mischa, he has poetically good looks, soulful blue-grey eyes, a Russian love of laughter with a hint of mischief thrown in, and the steely determination which he brings to the way he runs his career and the American Ballet Theatre. 'I love the ballet, but I must have a life away from it. I have a house in the country near New York, where I can go to listen to music and see the trees. I go there a lot just to be private. It is good for my soul. You see, I am still a Russian at heart and always will be.'

ALAN BATES

Alan Bates has achieved pretty well everything the stage or screen can offer him except a musical. It was a surprise to discover how nearly this prospect came about, as he had been working with Alan Jay Lerner until shortly before the lyricist's death. 'Alan had written a piece he wanted me to do and we were involved in it up to the point when he was taken ill. We went through the songs together and there was some wonderful stuff in it. But after his death the project passed into other hands and went away from me.' When questioned about the quality of his singing voice, he offered the reminder of the burly baritone he let rip with briefly in the film The Go-Between.

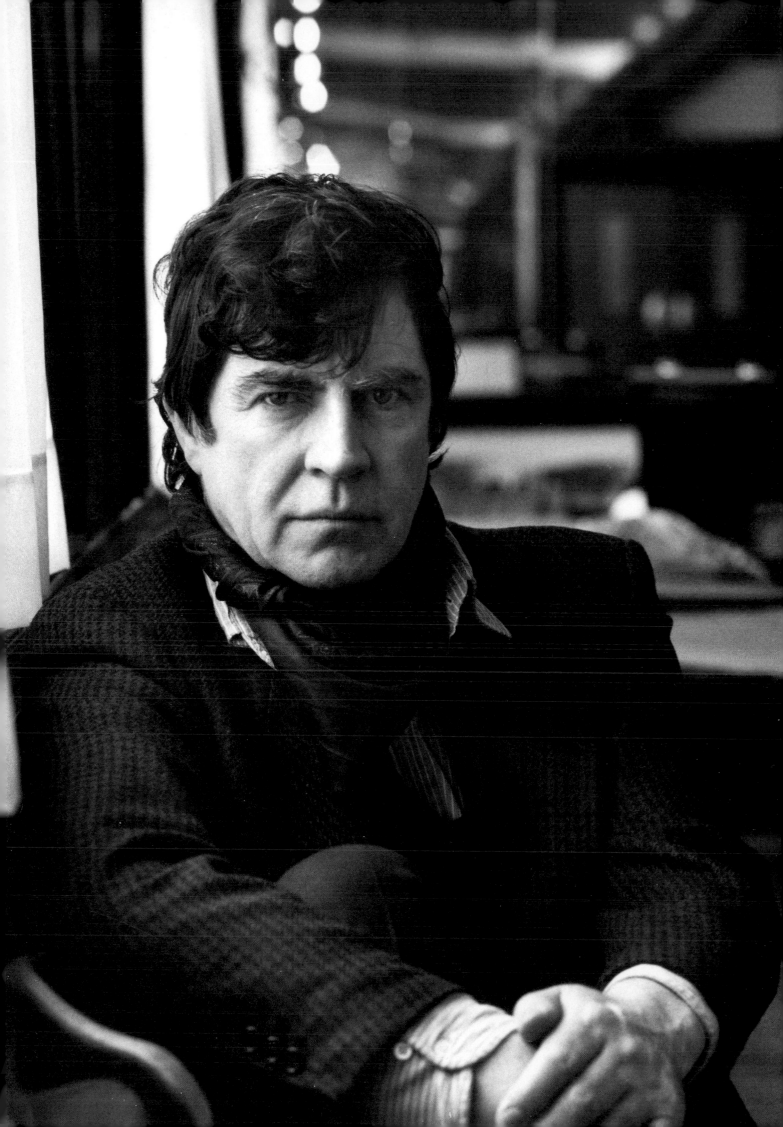

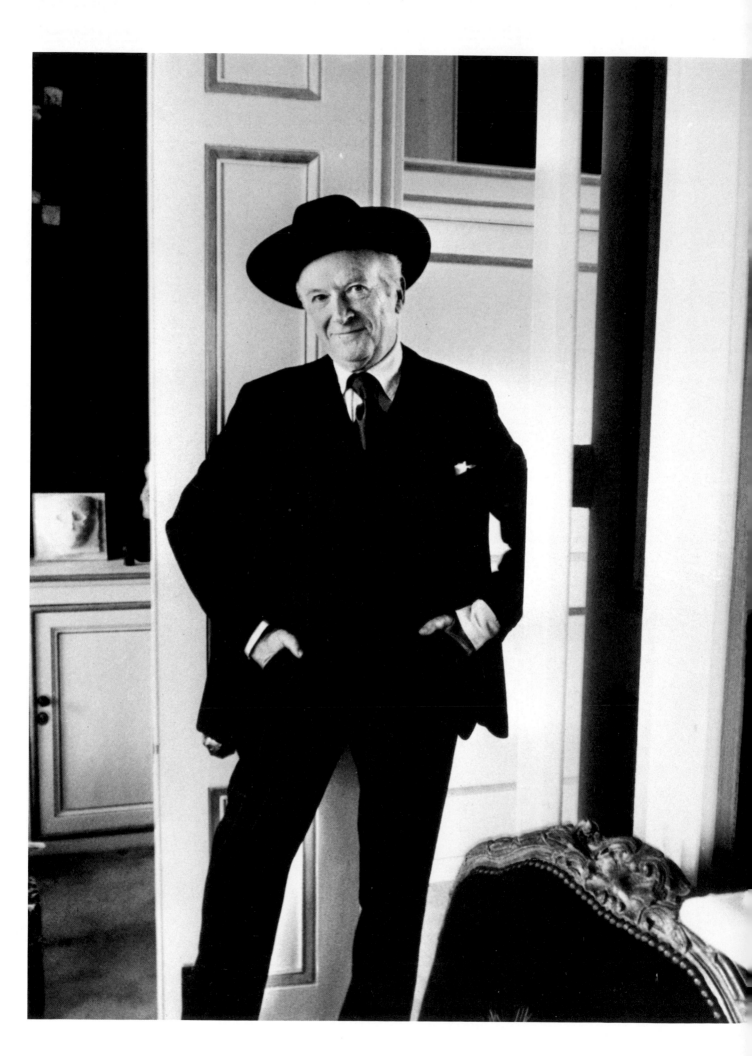

SIR CECIL BEATON

Beaton, photographer and designer par excellence, was also a famous gossip as revealed in his Diaries where, among others, he ran through his rows with Laurence Olivier, why Greta Garbo did not marry him and how Lady Bingham ended up naked on the luggage rack of a train between Salisbury and London. Was he not rather sharp about people? 'I say sharp things, but I'm sure I don't intend them to be hurtful. The intention is not to rap over the knuckles. I have strong likes and dislikes. Certain people earn my displeasure. I can't like everyone all the time.'

INGRID BERGMAN

Ingrid Bergman was in London after completing what she firmly declared to be her last film, but without betraying any sign or knowledge of the cancer which was later to claim her life. The film was Autumn Sonata, which paired her for the first time with her namesake, Ingmar Bergman. Despite their common background, the pair hardly knew each other. She said: 'I thought he was going to be diabolical. That's his reputation, but he was so kind. It's the most interesting film I have ever made and I said to myself when it was finished that I don't want to make another film. It makes a nice end to my movie career.'

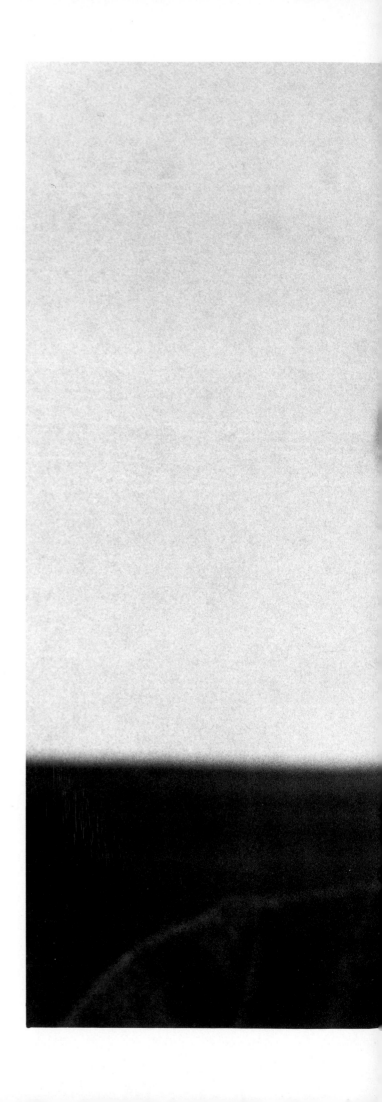

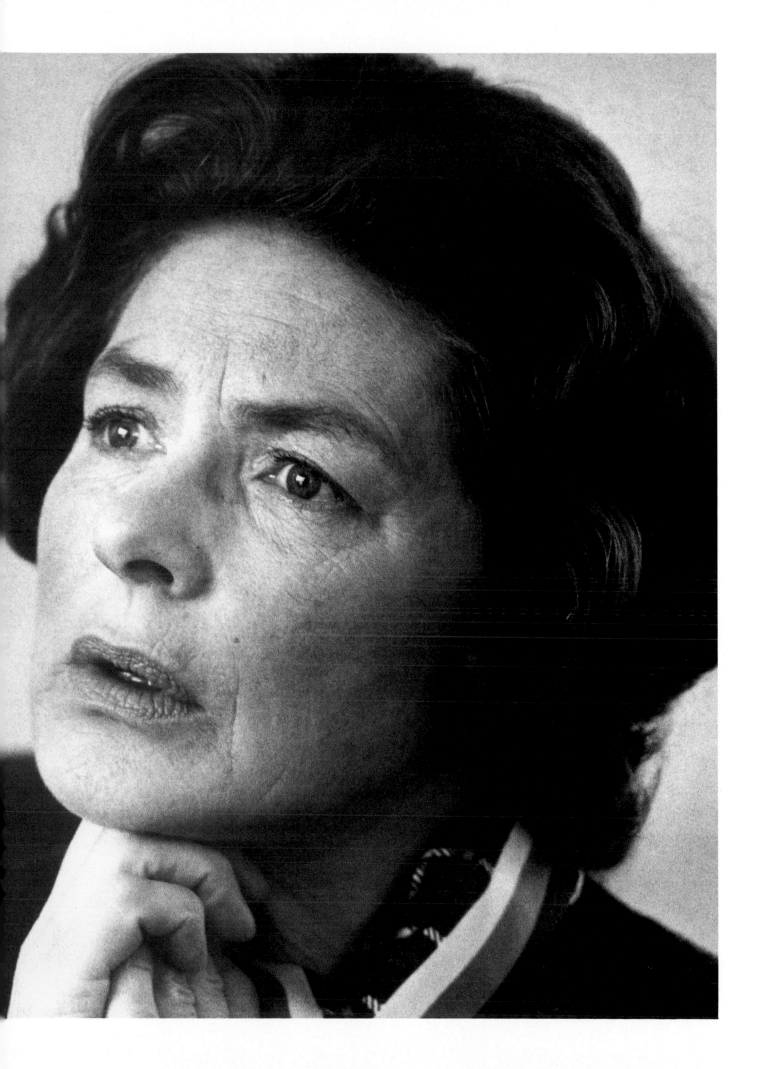

DIRK BOGARDE

Dirk Bogarde has actor written on his passport, but on the tax returns he sent from his home in Provence he described himself as a writer. It is part of the changing contradictions of the man who for a decade or more was the No. 1 star of Rank Films in England, then emigrated to make a series of admired European movies ranging from Death in Venice to Providence, before re-settling into an occupation as author producing several editions of biography as well as novels. He became increasingly disparaging about his first career. 'I do not like acting very much. I never have, but I skidded through and it made me money. That's all I can say.'

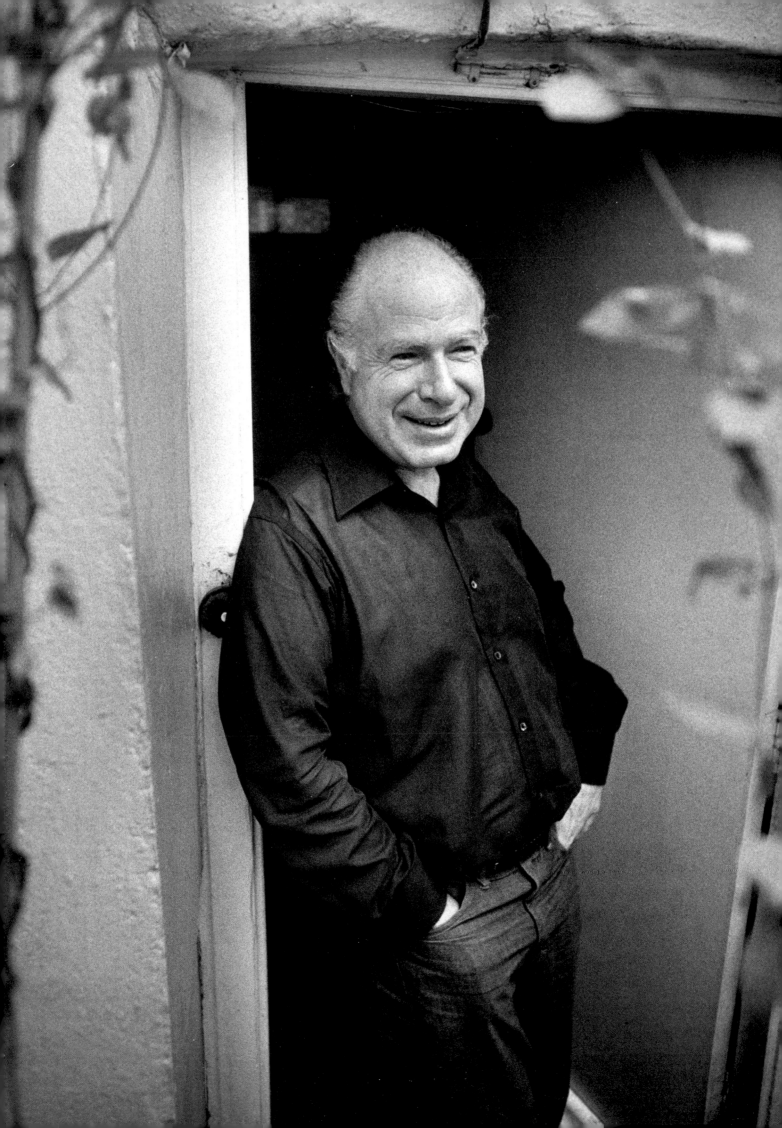

PETER BROOK

He is Buddha, the guru, the mystical man of modern theatre exploring the depths and frontiers of drama - as he did with his ten-hour version of the Indian classic The Mahabharata *- and so to be treated with almost holy reverence. Some do. He doesn't. 'I've always thought of myself as rather a jolly person and I can be a bit of a giggler.' He did giggle when he told with relish a story against himself concerning a recent visit to Leningrad: 'I was in a hurry to get to the theatre and particularly wanted to see a production of Brecht's* Arturo Ui *they had there. It was half an hour before I realized I was in the wrong theatre watching the wrong play.'*

RICHARD BURTON

Richard Burton's shoulders sagged, the proud head once held so nobly high sank towards his chest, and he walked slowly and with difficulty. Burton was in the middle of playing what was to be his last film, 1984 by George Orwell, and blamed his physical condition on a neck operation which had severed vital muscles which refused to heal. The old fire only came back when he started talking about the stage and of returning to Shakespeare - a familiar theme over the years - mentioning Othello and Prospero as favourite roles for a comeback and admitting that King Lear was now beyond him. Then he defused it all by saying: 'Of course, people are always trying to shove me back into doublet and hose.' He never did make it back to the stage. Tragically, he died two months later.

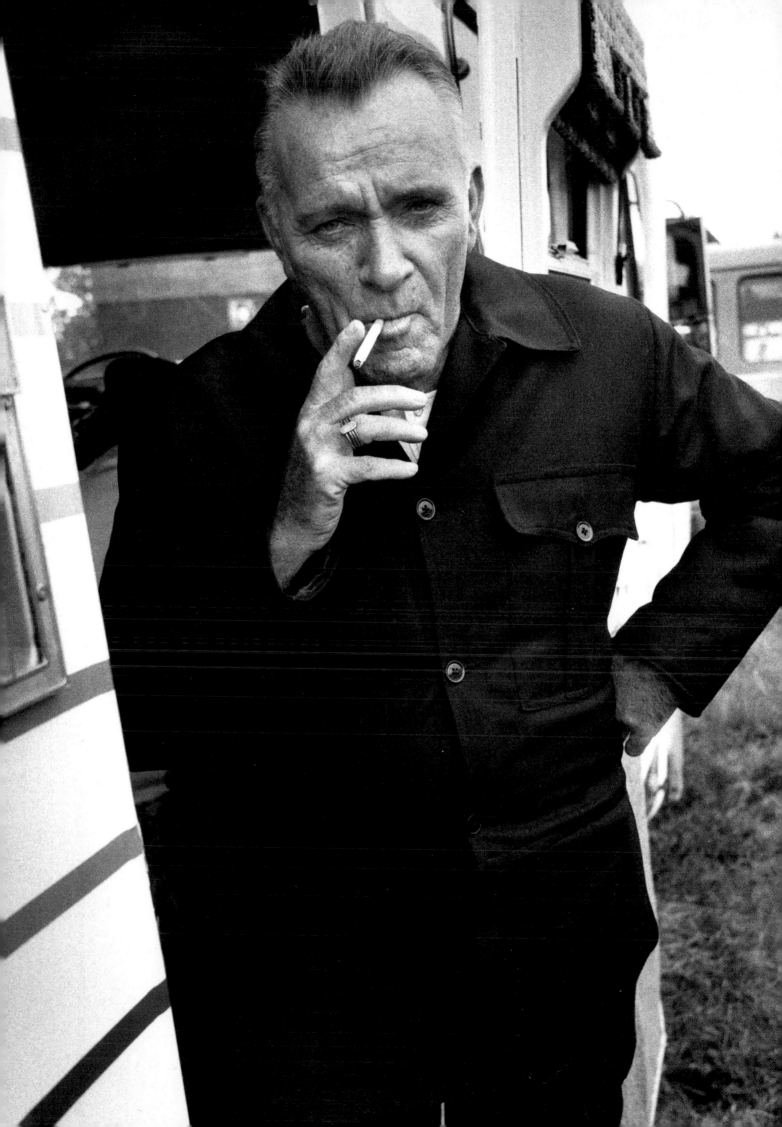

JOHN CLEESE

He was the most manic of the Monty Python team and his own personality tended towards impatience and self-preoccupation, so do gifted comedians necessarily have to be tormented? Not any more, said Mr Cleese, when he emerged a tranquil, going on saintly person after three years of psychotherapy. 'I'm happier with myself now than I've been for years. The therapy had a great deal to do with it. When you sit down and examine how you work you can find a better way of making yourself work better. I believe in making a living and having a little humour while you are doing it.' As he spoke he was holding his own script of what would become his biggest, international success - A Fish Called Wanda.

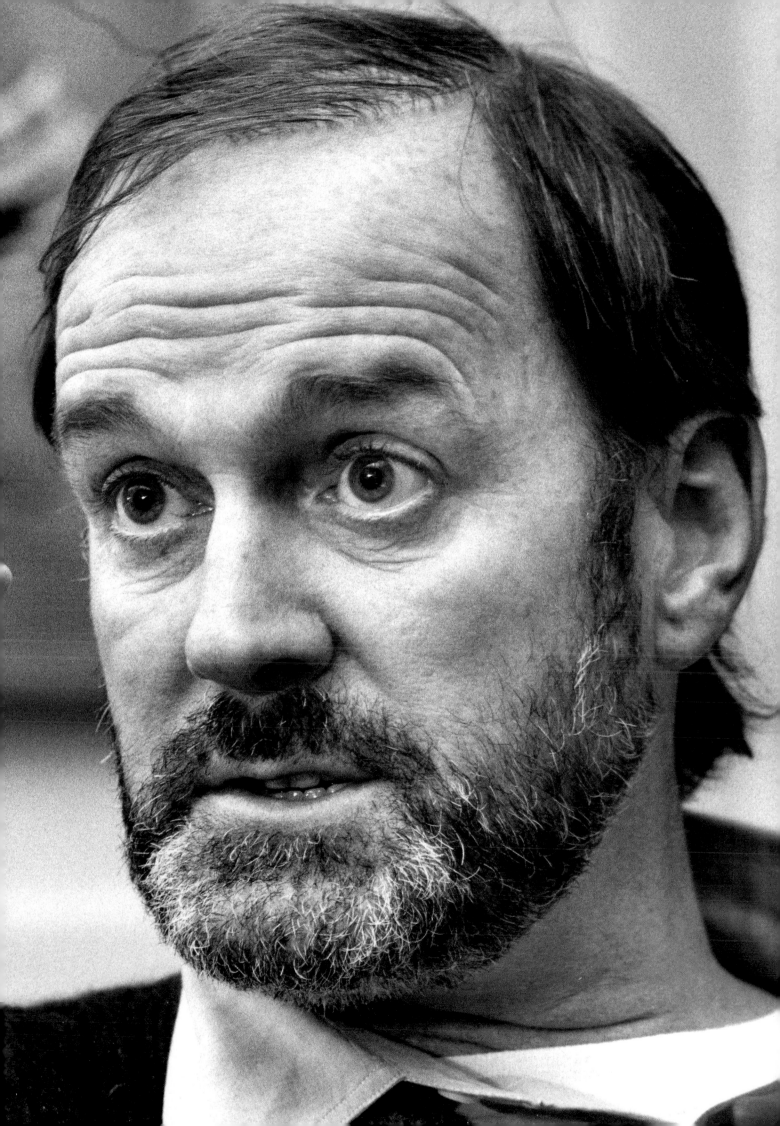

SEAN CONNERY

Sean Connery never did suffer fools gladly and the look of disdain he summoned up at what he took to be the rudest of social gaffes could have killed. He was at his most welcoming when he opened the front door to his apartment looking out over the Thames at Chelsea. 'Fancy a Scotch, boys?' he asked as he led the way to the lounge. Now, the very Scottish Mr Connery has a refined palate when it comes to the Highland nectar and has his own private brand of malt whisky. When Jones asked for water with his and I, even worse, asked for soda, his eyebrows descended and his face darkened: 'Well, if you must. Now what do you want to know?'

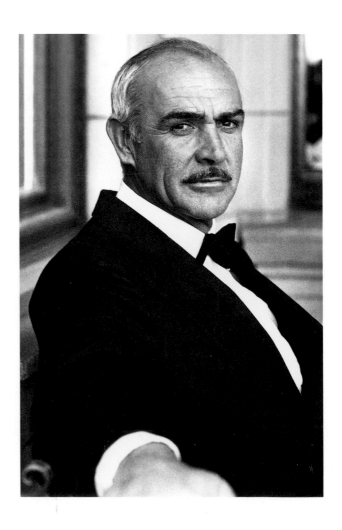

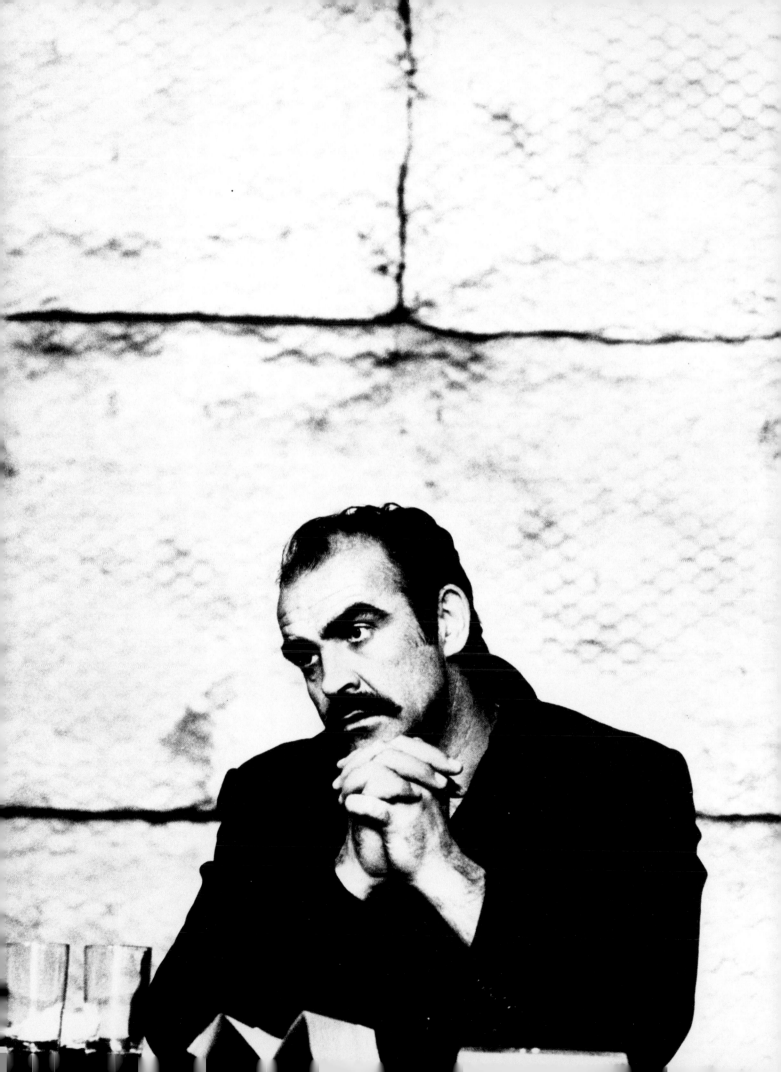

SIR NOËL COWARD

The Master's celebrated, wicked sense of humour took multitudinous forms, but he always took particular pleasure in some naughtiness which occurred during the first run of Private Lives *in which he starred with Olivier. 'I have one great thing to my credit in life. I stopped Larry giggling on stage. When we used to act together I'd suddenly do something different and he'd break up laughing. I finally broke him of it. I did* do *some terrible things. In the fight scene in* Private Lives *when he took his jacket off with a flourish I once murmured "Take me." Then I invented a terrible dog called Roger. I used to mutter to him quietly: "What* are *you doing, Roger?" He got used to it eventually and never giggled again.'*

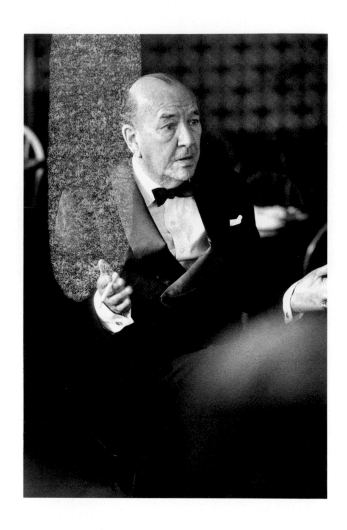

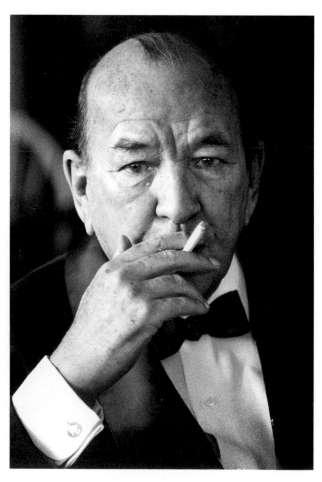

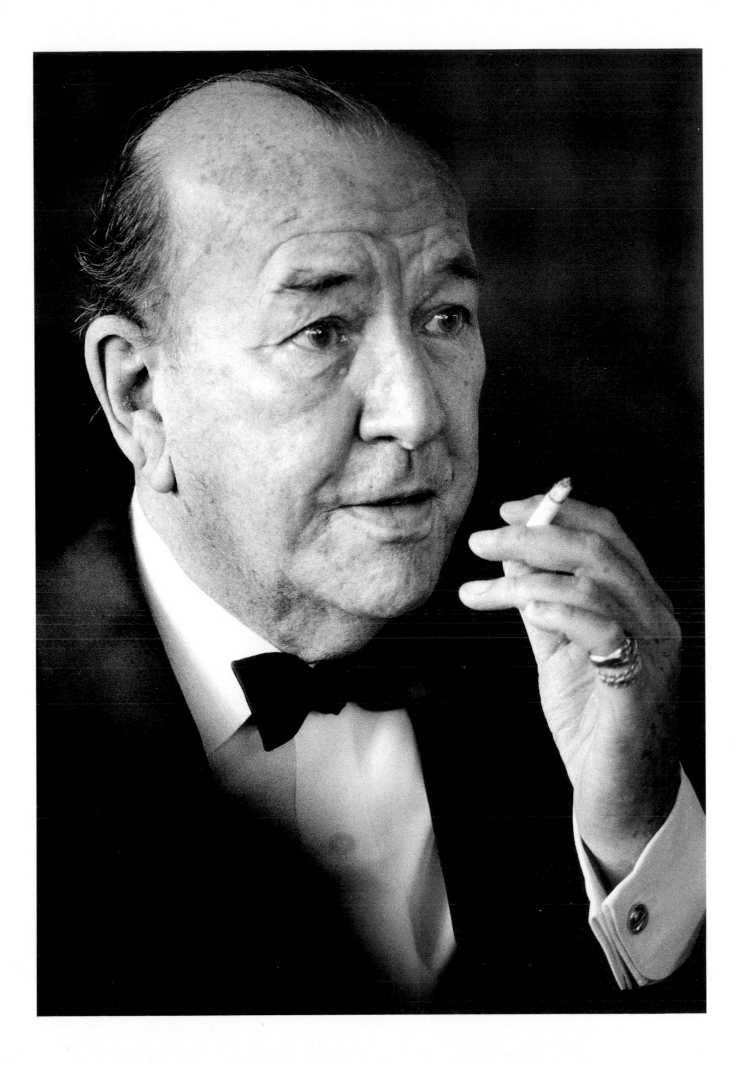

TONY CURTIS

Disillusioned with his film career, feeling used and abused by those around him, Tony Curtis took a three-year break from movies ending with an attempt at a Broadway play, which closed on its out-of-town tour. He described it as one of the lowest moments in his life. 'I felt very alone and despondent at that time. I'd gone into it with all the energy at my command and been handed my head back on a plate. I was a basket case by the end. There is nothing you can do about it. It is just the nature of the business.'

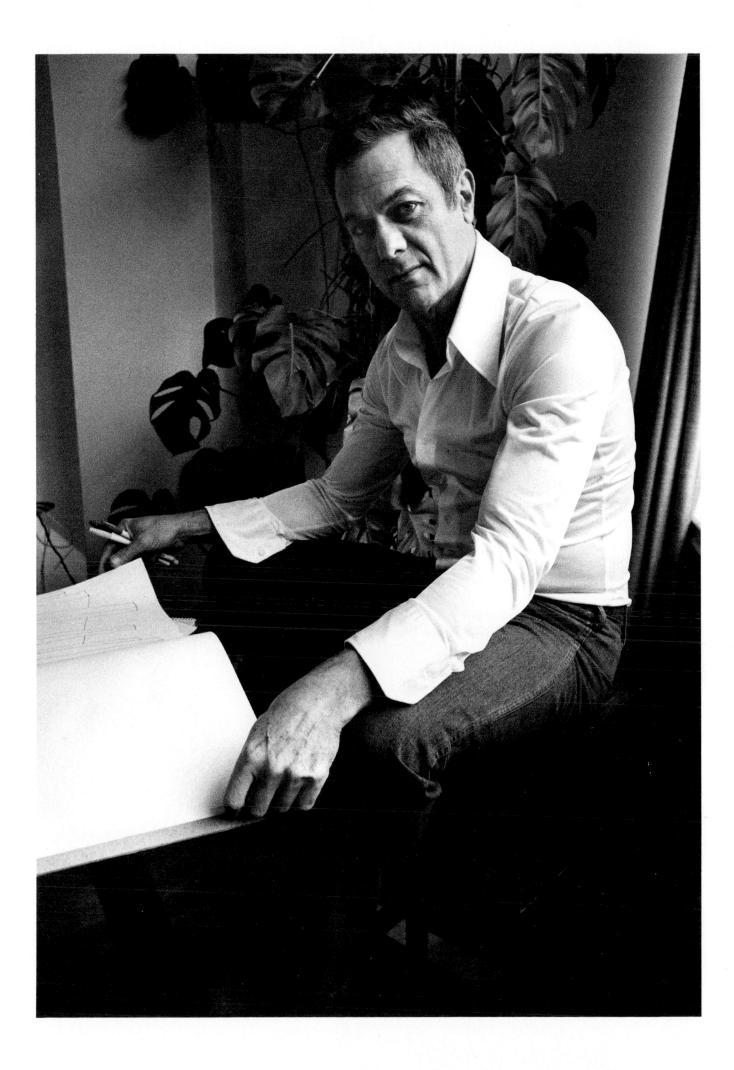

ALAIN DELON

He has the film star good looks, the Gallic charm and - as if he needed any more - the suspicion of notoriety over alleged complicity (which he has always strenuously denied) concerning the death of a bodyguard whose corpse was found on a Paris rubbish dump. All of which makes Delon irresistible to women, it seems. But what is his attitude to the opposite sex? Rather harsh is the answer. 'For a woman the best part of life is between twenty and thirty. For a man it's completely the opposite. His life starts at thirty and he keeps getting better the older he gets. At my age now I am at my peak. A woman of the same age who could exist like me simply does not exist.'

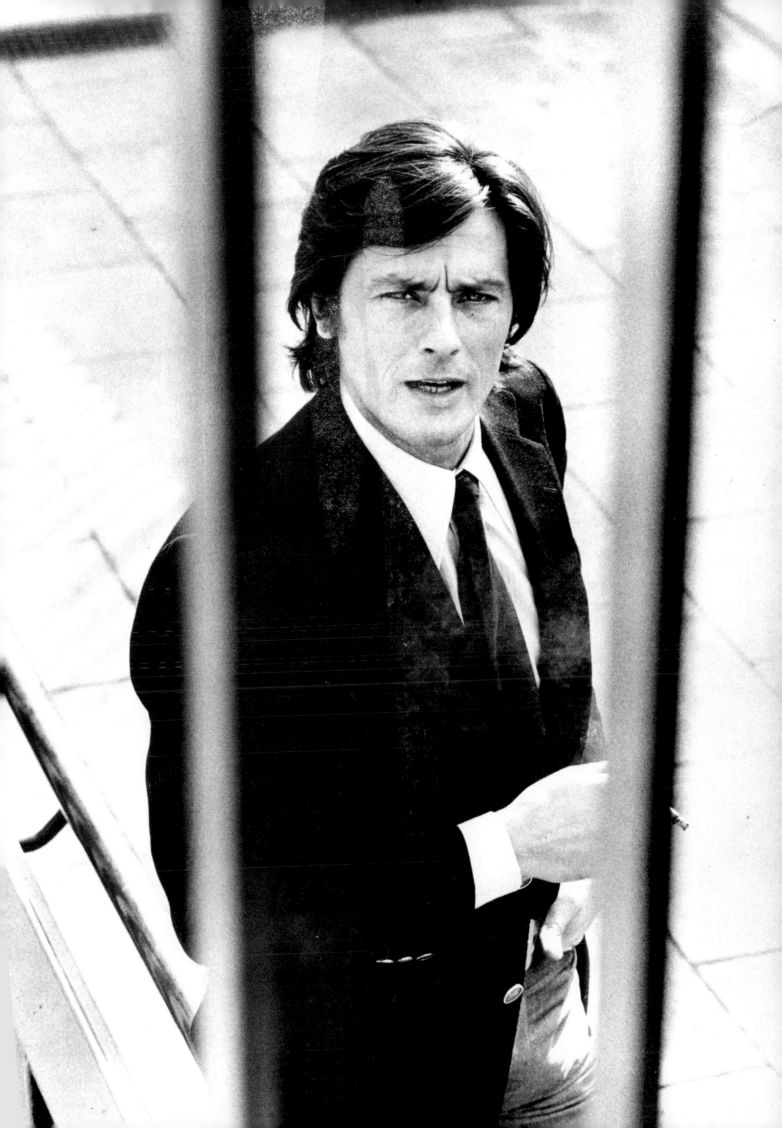

PLACIDO DOMINGO AND DAME KIRI TE KANAWA

The pair were about to play the doomed lovers of Puccini's Manon Lescaut *when, because they know each other so well, they were asked what they felt for each other on stage while singing a love duet.*

KIRI (laughing): 'Watch it now. What exactly is that supposed to mean?'

PLACIDO: 'We are the best of friends.'

KIRI: 'We have great respect for each other, but on the stage even if we hated each other's guts we would still make it come out that we loved each other. If we really loved each other it might come out too natural and not reflect what was needed.'

PLACIDO: 'Don't forget I know Kiri and her husband and she knows my wife.'

KIRI: 'If you and I were having a mad, passionate affair and trying to keep it secret it still does not mean the love scenes on stage would work In fact, we are good friends and not having a mad, passionate love affair. My husband wouldn't like it and sure as hell your wife wouldn't like it. There would be big trouble. So we'll just stay good buddies.'

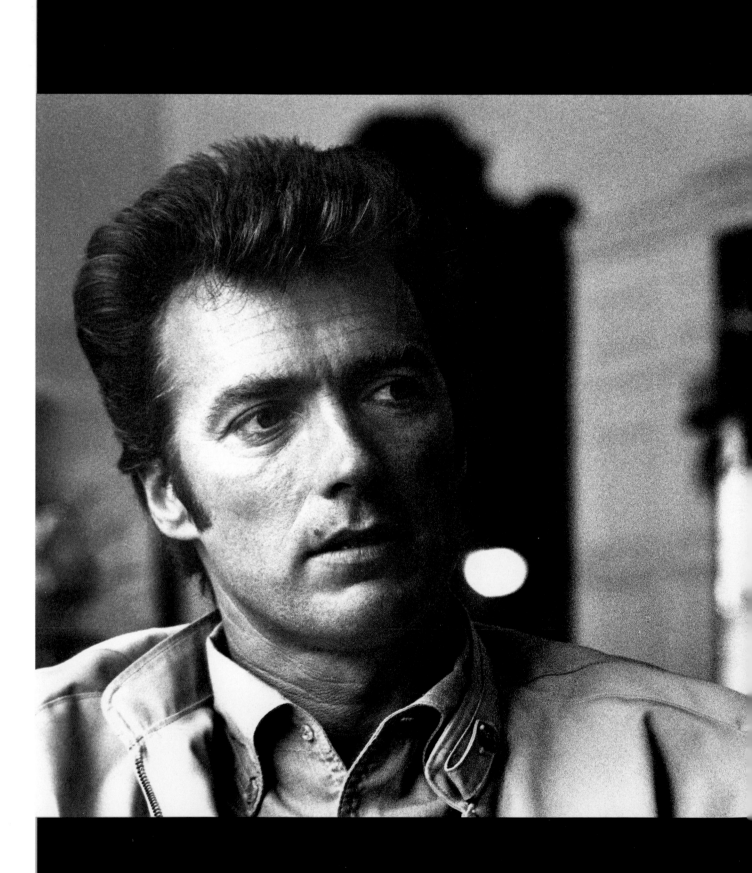

CLINT EASTWOOD

Clint Eastwood was wearing sneakers rather than cowboy boots, but at 6ft 4ins he still cast a long shadow. At the time he was second richest cowboy in the movies, but would soon be ready to overtake John Wayne. It was the 'spaghetti Westerns' filmed in Spain which made the difference. Eastwood had made his name as Rowdy Yates in the TV series Rawhide. *He explained what happened next.*
'After Rawhide *someone offered me a part in Spain in a Western made by an Italian-German company based on a Japanese Samurai story. I said: "You must be kidding." But I was intrigued and as I'd never been to Europe before I thought what the hell. It was the best move I ever made.'*

DAME EDITH EVANS

'Sprout tops? Do you like sprout tops?' The unique voice of Dame Edith Evans echoed through the galleried lounge of her Tudor home in the Kent countryside. She was serving a lunch of roast chicken and apple pie from a sideboard and wanted to make it clear that we were the first journalists to be allowed into her house - 'My husband always said that if a photographer came up the drive he would shoot him' - and that lunch was made up of produce from her own garden. In her eighty-fifth year and on the eve of what turned out to be her last West End show she was so animated in conversation that she forgot the chicken still waiting to be carved in the kitchen, so we dined on her vegetables, complimented her on her cooking and left the chicken to be eaten cold another time.

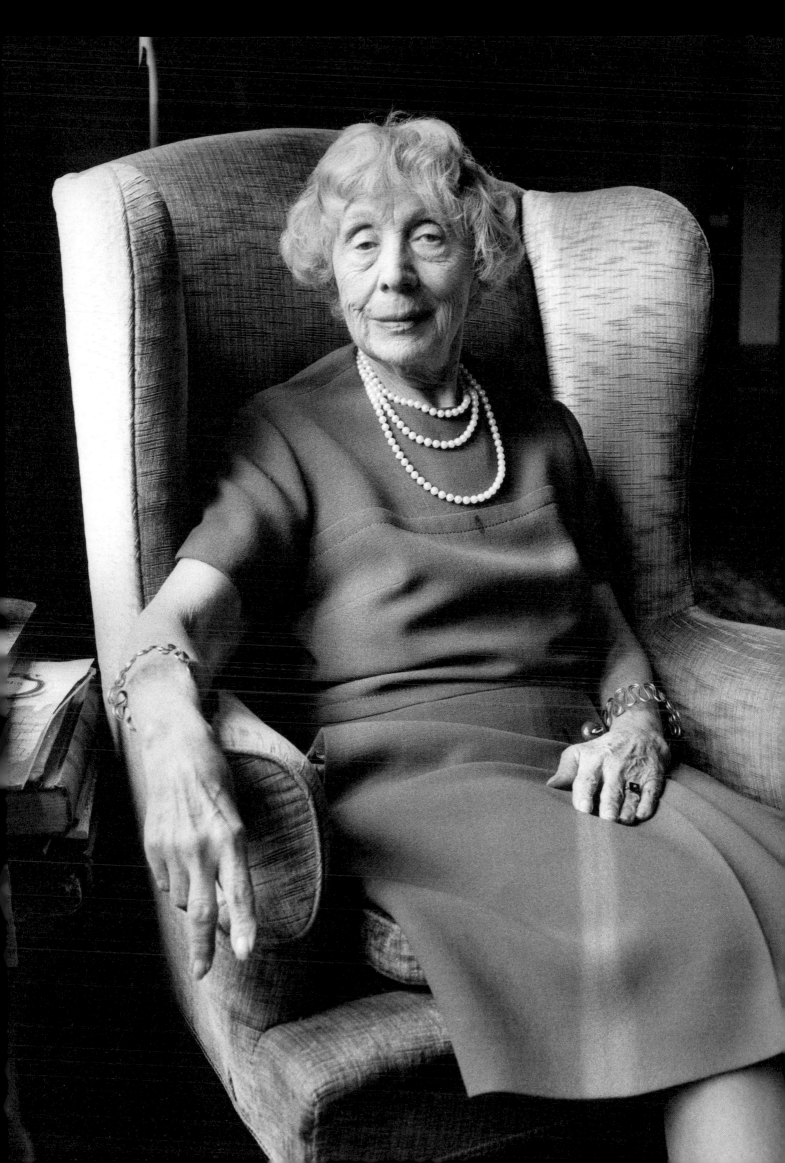

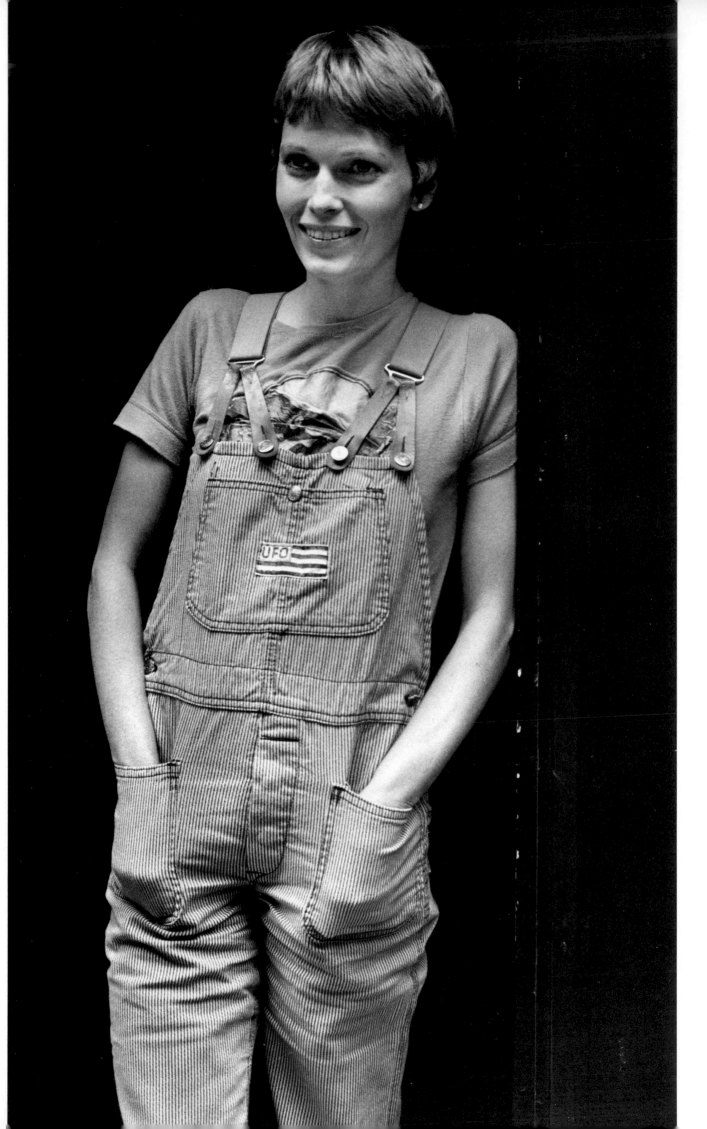

MIA FARROW

It was after the Sinatra days and Rosemary's Baby and before the involvement with Woody Allen and his films that Mia Farrow sought to make herself a member of the London acting community. She began in some suburban theatres, where the chief impression she left behind was the enormous volume of voice emanating from such a tiny frame. Then she joined the Royal Shakespeare Company. After an early rehearsal she went off in her boiler suit and braces to a London pub. 'I'll have a port, please. I'm told it's good for the voice.' She was honest about joining the distinguished ranks of the RSC. 'Trepidation? Call it fear. I'd be a fool not to be frightened. I've too much respect for the people and what goes on here.' Miss Farrow survived her introduction to the RSC and stayed with them for eighteen months.

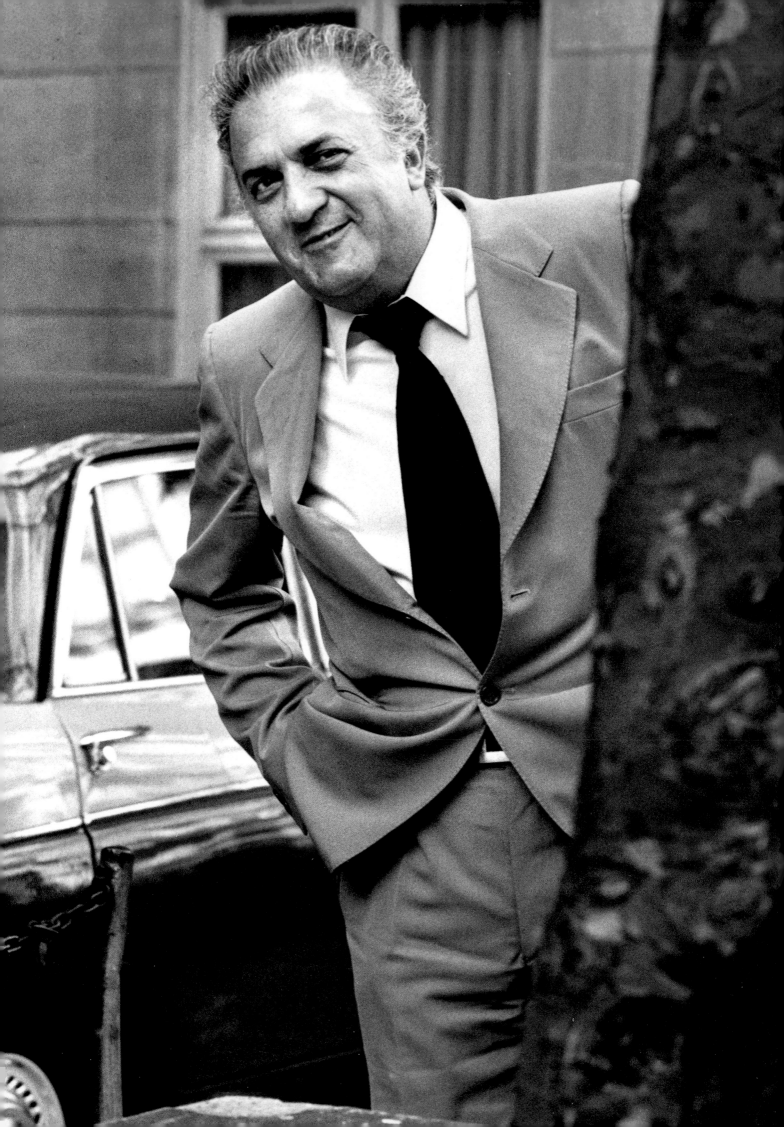

FEDERICO FELLINI

That most Italian of men and flamboyant of directors has always expressed a curious admiration for the normally staid and distinctly un-Latin English, but on a visit to London he explained his uniquely personal perceptions: 'I find English people are exotic. Everything is clownish. They are trained not to show the interior side, not because they must keep a secret but not to disturb, not to interfere. I find this fascinating. For me, as a writer and director, I want to know what is behind the good manners and soft voice. Who is inside the silhouette?'

ALBERT FINNEY

'If,' said Albert Finney, with a heavy emphasis on the single syllable, 'if I have a responsibility it is to live my life as I see it and feel it and to go where it leads me.' The man who was looked upon as the natural successor to Olivier works in intense bursts and then disappears for months, years even, at a time to look after his race horses, enjoy the social round or vanish into jungles of the world. He makes no apology. 'Look, this is a very unpredictable business, a very insecure business. I don't know where I'll be in a year's time and, quite honestly, I'm not sure I want to know.'

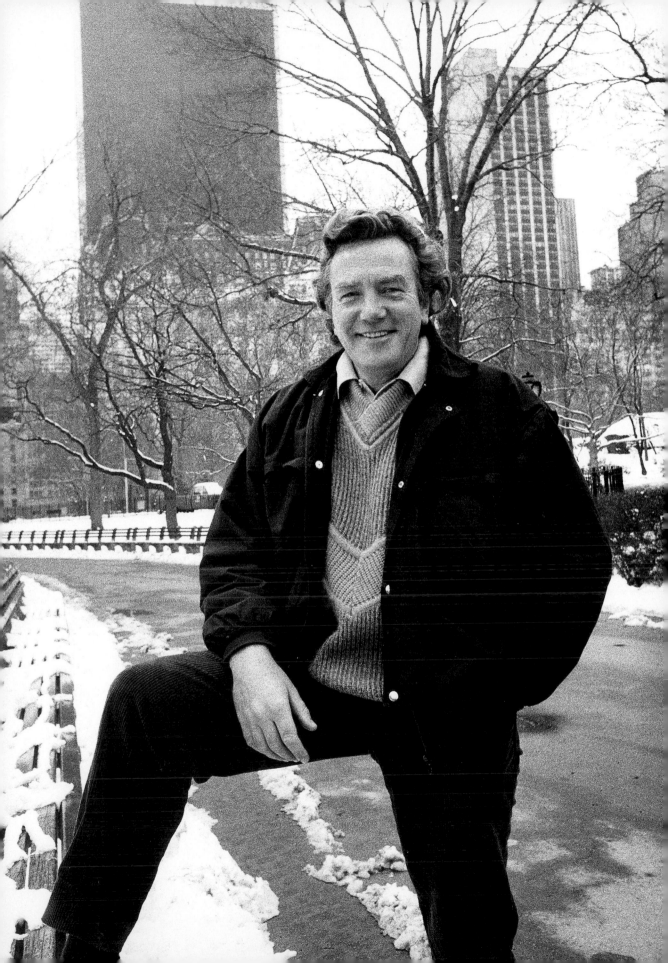

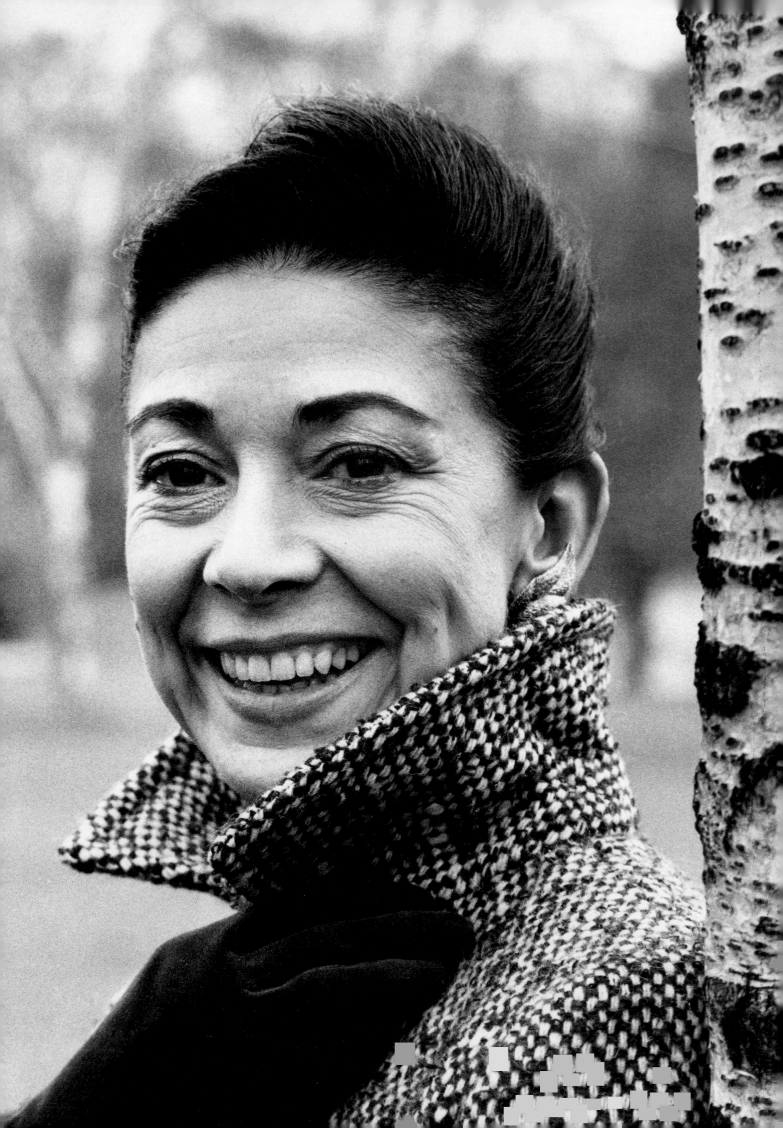

DAME MARGOT FONTEYN

The appointment to photograph Dame Margot was at the Royal Ballet School in Baron's Court, west London. Jones duly arrived and the photographs were achieved, but then Dame Margot surprised him by seeking a favour: could he possibly give her a lift to Bond Street, where she was going to do some shopping? Jones was at that time driving a particularly battered and none-too-reliable VW Beetle. He set off for the West End with Dame Margot at his side and the world's most precious legs squeezed beneath the metal dashboard. He has never driven so carefully in his life.

SIR JOHN GIELGUD AND
SIR RALPH RICHARDSON

In the grounds of a stately house in Hertfordshire, the two great knights of British theatre were reunited for a film which never found a release – and perhaps they knew it. Sir Ralph, the benign eccentric, was in impish mood, teasing jokes with the crew and chasing cloud patterns across the lawn before disappearing through a hole in the hedge not to be seen for another two hours. Sir John kept a more contained presence alternating private reading in his dressing-room with bouts of animated gossip. Sir Ralph was not in the mood for serious interview, but Sir John reflected interestingly on his lifelong friend. 'The thing about Ralph is that he is an extremely shrewd man. He gives the impression of being a bit vague, a bit bewildered, but he isn't at all. He sees everything, he is so quick and alert on the up-take. You have to watch him very closely.'

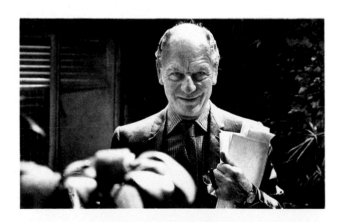

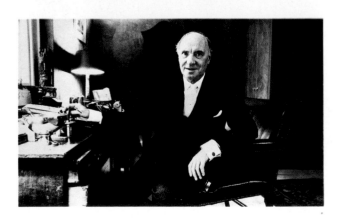

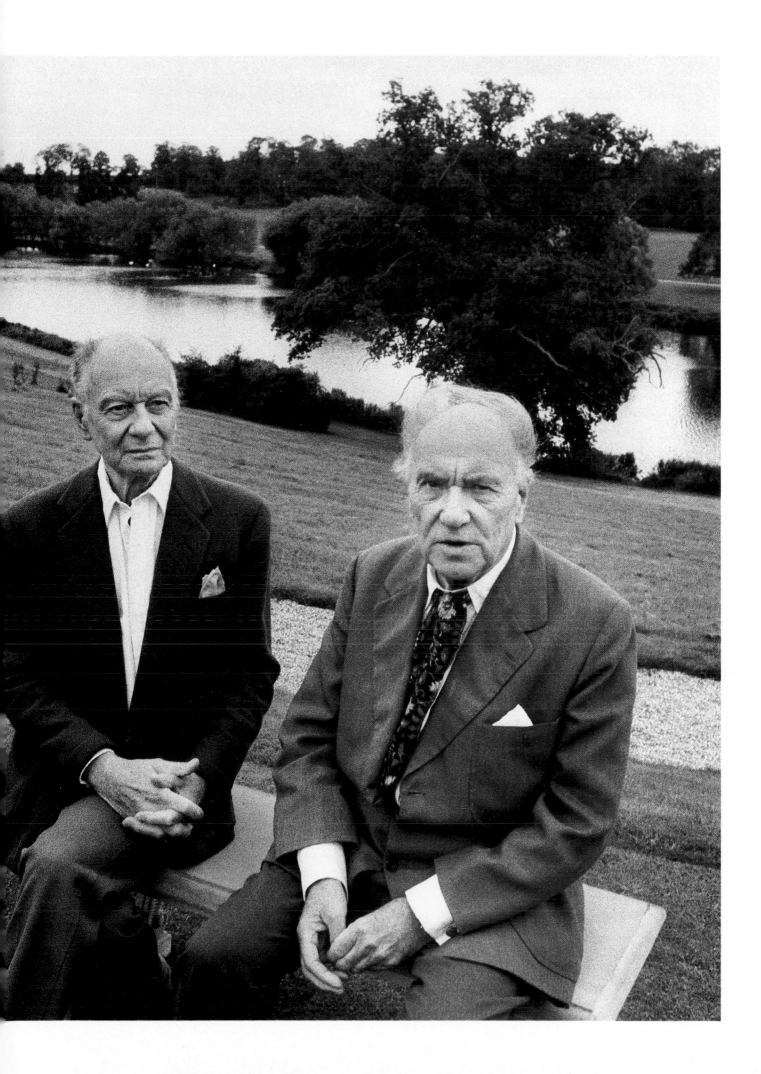

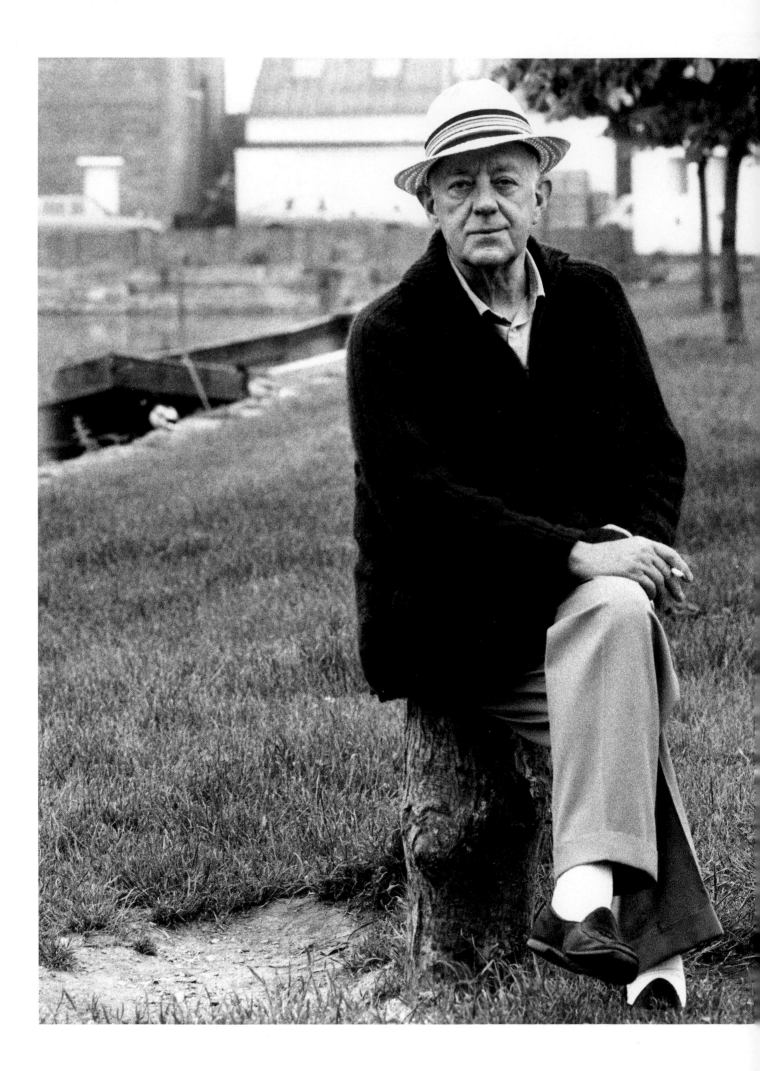

SIR ALEC GUINNESS

On the night Sir Alec received his Oscar for a lifetime's achievement in cinema he embraced that good, old-fashioned sense of English understatement which has sometimes informed his acting and more often his own personality. He told that ripely, richest of audiences that he had learned to do less and less in front of the camera until he finally discovered how to do nothing at all and, therefore, he did not deserve the award. He is known as the chameleon of actors, who somehow preserves his anonymity and, for all his achievement, that Oscar night of self-effacement was entirely in character – this time, his own.

SIR PETER HALL,
LORD OLIVIER,
KENNETH TYNAN

In 1972 Sir Laurence - later to be Lord - Olivier was approaching the end of his directorship of the National Theatre, which he created. He expected to be involved in appointing his successor, but Lord Goodman, chairman of the Arts Council, and Lord Rayne, chairman of the National Theatre, approached Sir Peter Hall without Olivier's knowledge. Kenneth Tynan, the former critic who had become Olivier's literary lieutenant, rushed to the barricades, saying that Olivier should press for his favoured candidate, Michael Blakemore, or even his wife, Joan Plowright, to take over the company. But the job went to Hall. This photograph was taken when the three combatants appeared together in public for the first time - and the tension is tangible.

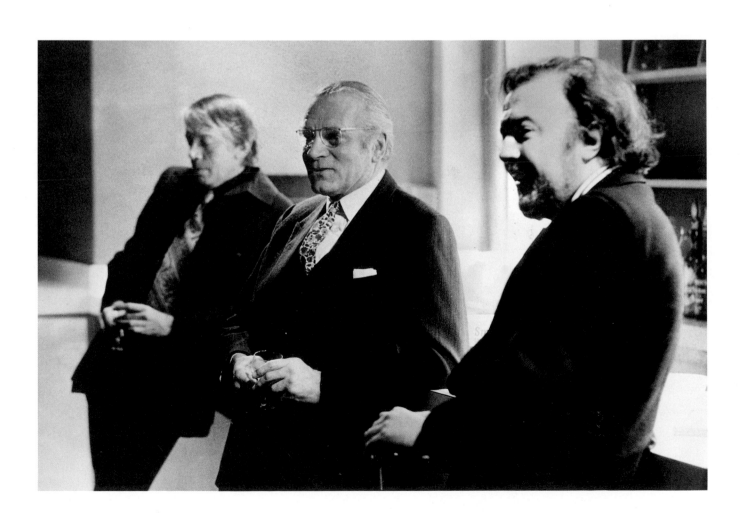

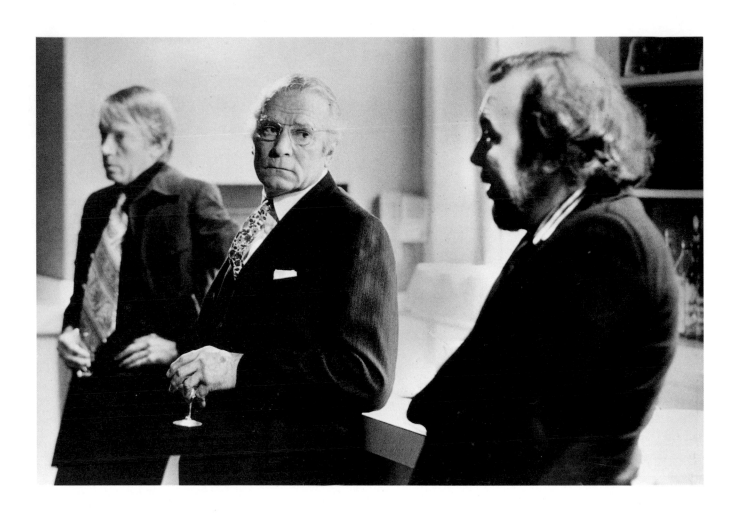

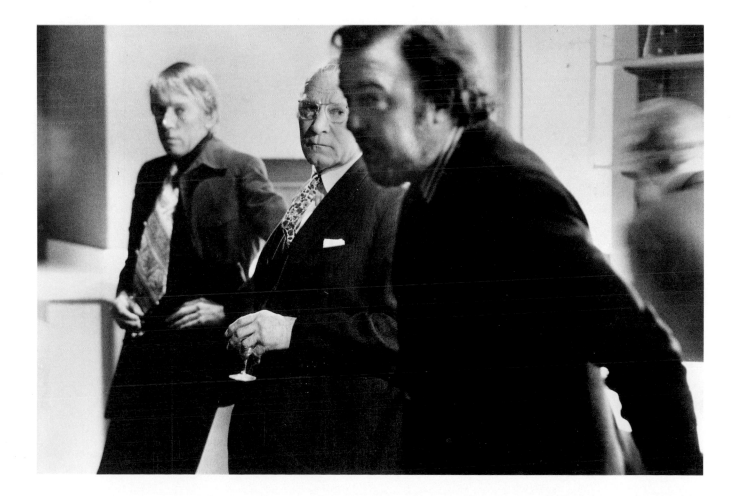

REX HARRISON

The graceful curve of Bath's Royal Crescent has a
stately nobility and a handsome classical line now
seasoned and weathered by the processes of time.
The same is true of Rex Harrison. The two were
brought together when Harrison toured a revival of
Shaw's Heartbreak House, *which drew memories*
of a meeting with Shaw during the filming of Major
Barbara. *'It was very intimidating for a young*
actor like myself to have the great man there, but
I think he was fascinated by this new world of film.
Anyway, he terrified the life out of me. I can see him
now, this tall, imposing figure with the white hair
and beard, piercing blue eyes and beetling eyebrows.
He looked very impressive and, as ever, was full
of awfully good advice.'

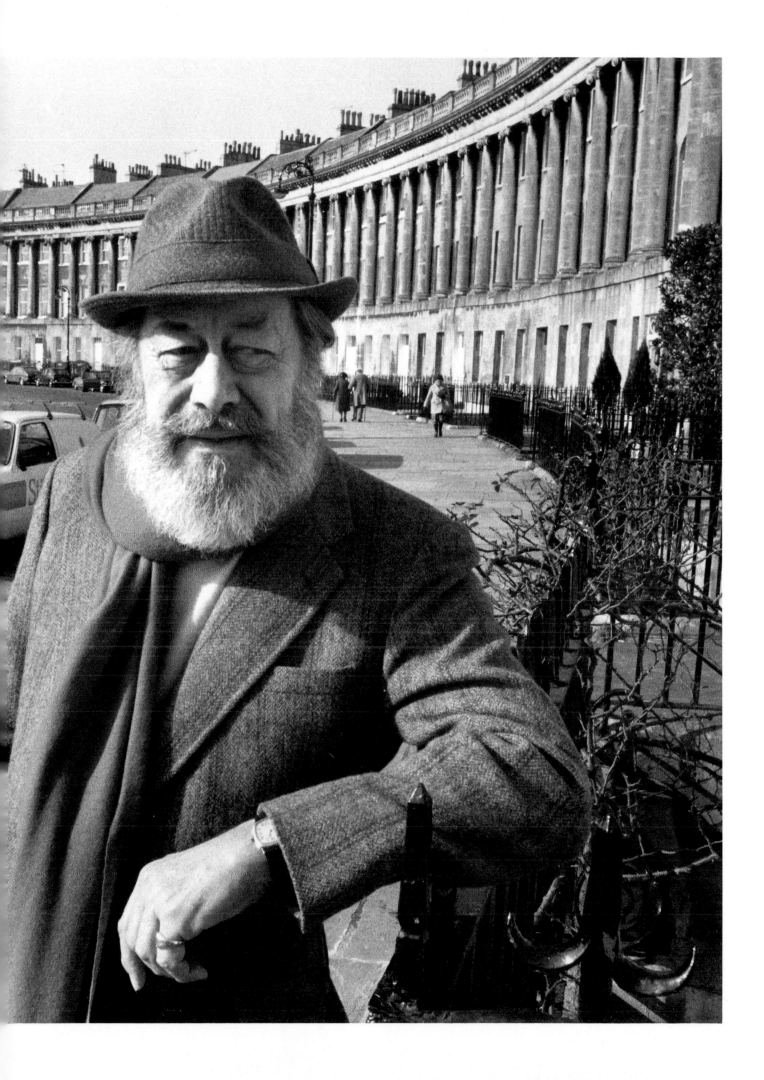

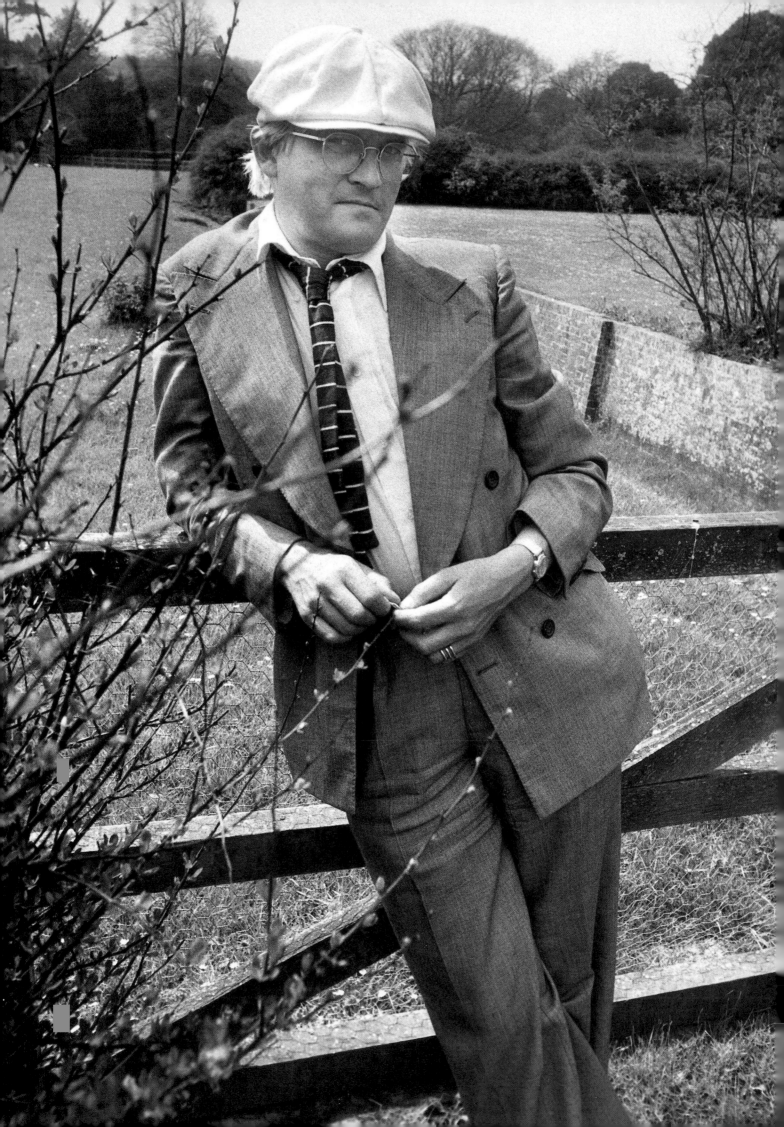

DAVID HOCKNEY

'Cum and see me dragon,' said David Hockney
with all the Yorkshireness which has never left him.
He gestured towards a 10ft monster, which looked
distinctly fearsome but some way removed from
familiar Hockney-land. 'Well, I pinched it from
Ucello's St George and the Dragon. Not pinched,
but adapted it.' This was late 1970s' Hockney,
when his painting had come to a standstill but his
career as an opera designer was burgeoning at
Glyndebourne - on this occasion with The Magic
Flute - and was to take him on to new operas at
Covent Garden, Los Angeles and elsewhere. Although
a devoted fan of opera, he is modest in his appraisals
- even though he wants to design a Ring cycle
one day. 'I don't know much about music. I'm just
an amateur lover of music. I can't read it or play an
instrument. Well, you can't do everything, can you?'

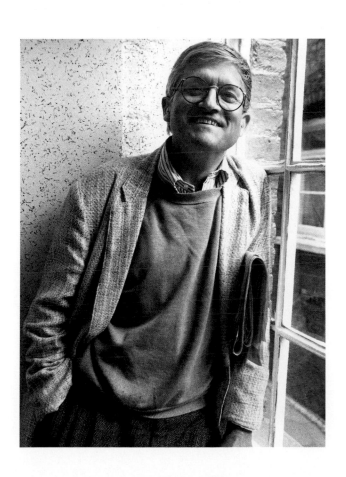

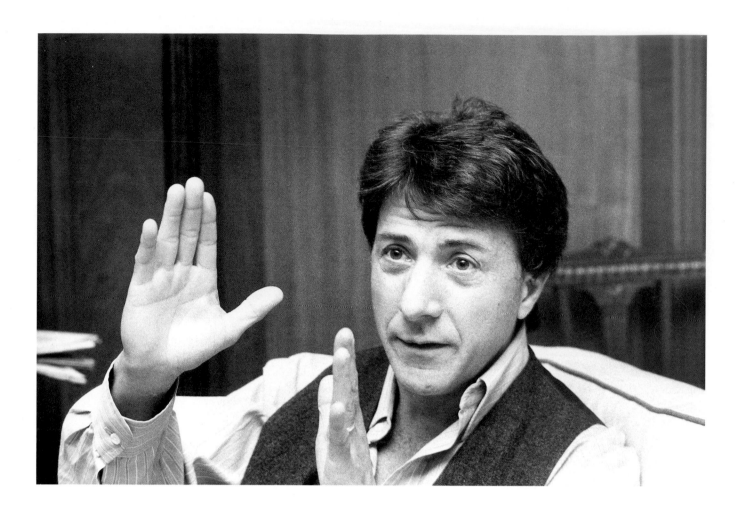

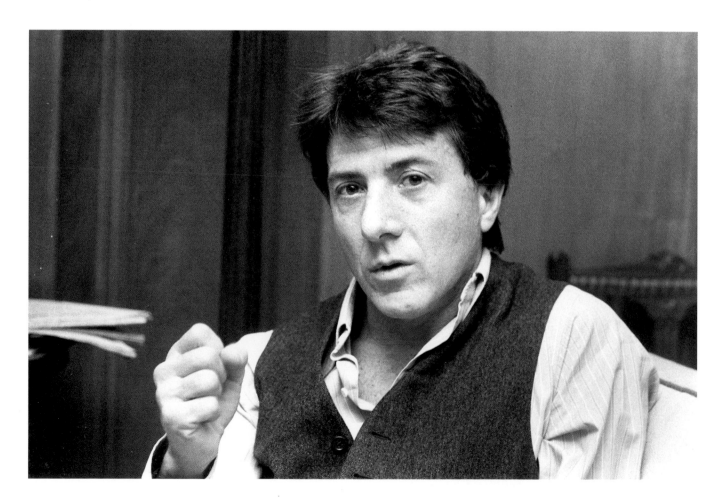

DUSTIN HOFFMAN

Dustin Hoffman was installed in a London hotel suite to publicize his movie Tootsie, but at his side was a most unusual book: an edition of Hamlet with the original text on the left-hand page and a translation into contemporary English on the right-hand page. He revealed that he had been studying it for a year. 'It's the only way we Americans can get into Shakespeare. I don't think we have ever cracked it in the past. We can't get the music of it, but I think there is an emotional side the English don't always get.' That was in 1983. Hoffman never did get to play Shakespeare on stage, but he did get on stage as Hamlet. But six years later he did put himself down most bravely, to make his Shakespearean debut in London as Shylock in The Merchant of Venice.

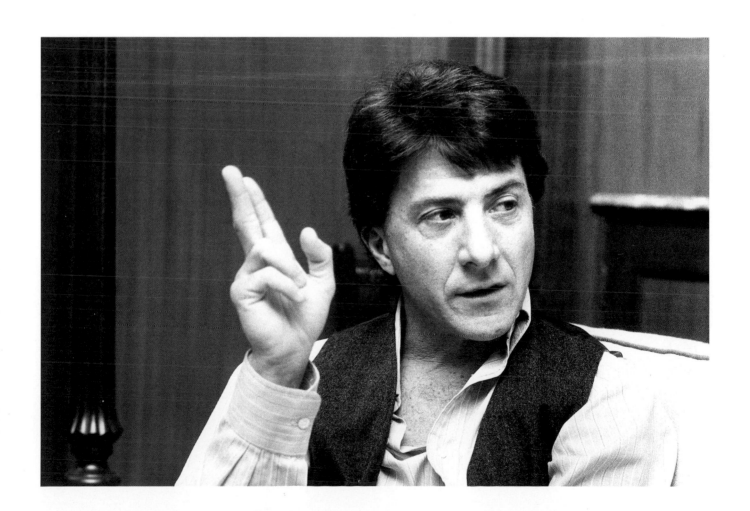

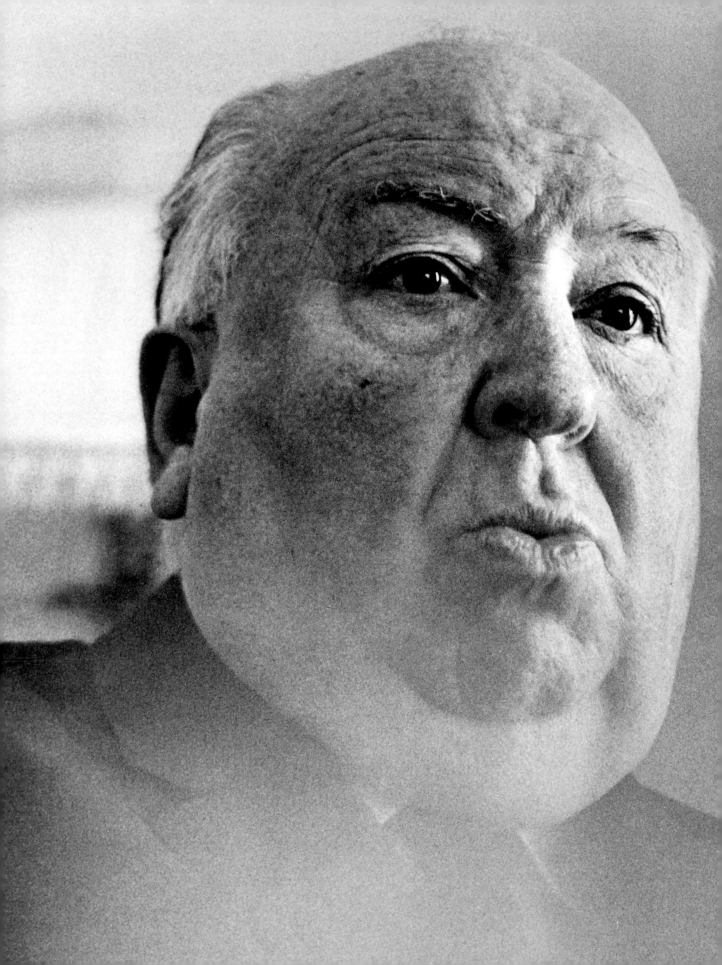

ALFRED HITCHCOCK

For a man whose films take their audiences to the edge of violence and danger, Alfred Hitchcock uses his own brand of plump benevolence as an avuncular antidote. He was back in London remembering how fifty years ago he had started as a caption writer in an Islington studio when suddenly he was given the chance to direct his first film. 'When it was finished the studio chiefs came to look at it. My wife and I walked round London for two hours. When we got back I was told the film was no good and would be put on the shelf. A few months later it was released and it was a success. I was able to carry on.'

ANTHONY HOPKINS

He used to be a rip-roaring boyo who threatened to emulate Richard Burton not just in the excellence of his acting but in the excesses of his lifestyle. Then he gave up drinking and smoking and the only addiction he confessed to was workaholism. 'I don't take myself quite so seriously any more. I used to be totally self-involved and arrogant, ready to hit anyone on the nose if I didn't like what they said. All that anxiety and tension has gone now. I'm happy to do the work and if people like it all well and good. If they don't, there is nothing I can do about it.'

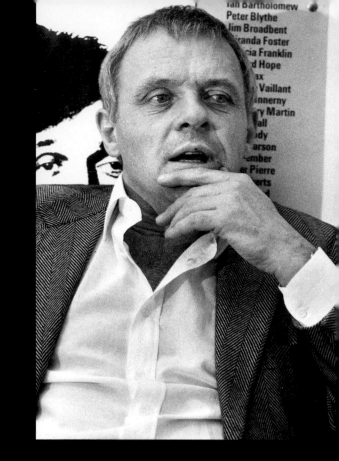

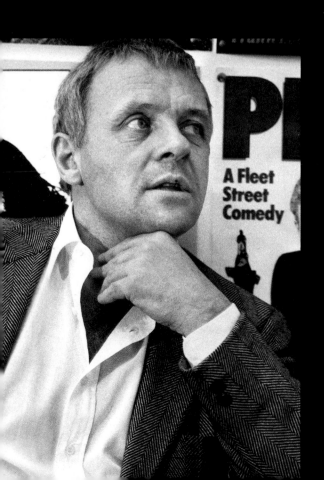

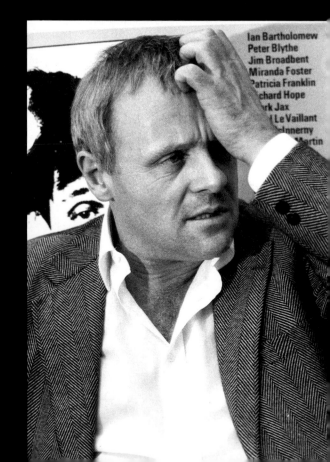

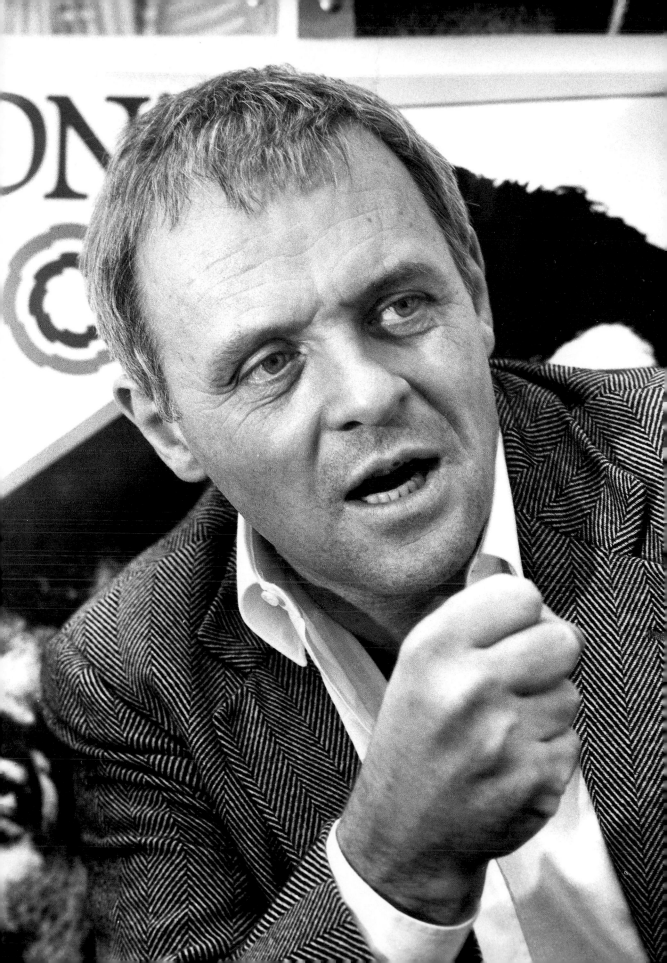

BOB HOSKINS

After an intensely varied career which ranged from being a Covent Garden porter and a window cleaner to a spell on an Israeli kibbutz and two weeks in the Norwegian navy, Bob Hoskins went for a drink with a friend at a London Fringe theatre. Somehow he was roped in to audition. 'Well, I was three parts cut so I thought why not.' An agent saw him and he has never looked back. Behind the bluff exterior there is an unlikely sensitivity. 'The best thing about this business (acting) is the people in it. They are prepared to get up there, have a go and say here I am, judge me. When you see some old guy of eighty getting up there and acting his socks off - Christ, it makes me proud.'

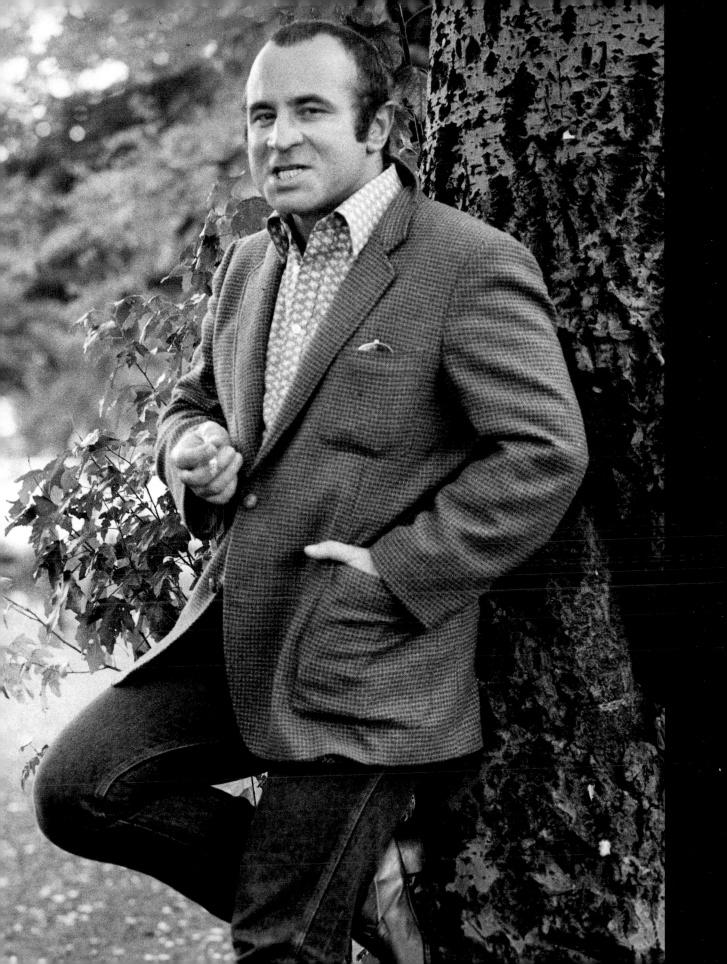

JEREMY IRONS

The cinema queues in London's Leicester Square did not know they had a star on their hands when the tall, lean, part-time social worker climbed off his bicycle to entertain them with his guitar. 'I'd do my Bob Dylan numbers and, on a good night, go home with a fiver.' Then he bugled his way down the aisle at the beginning of Godspell singing 'Prepare ye the way of the Lord . . .'. It was a preparation towards his own stardom, but one he wanted to take at his own pace. 'After the busking I was still prepared to wait. I did house-cleaning, gardening. I knew it was the right thing to do, to be patient. I still see all that has happened as something on the graph which will take me up to eighty.'

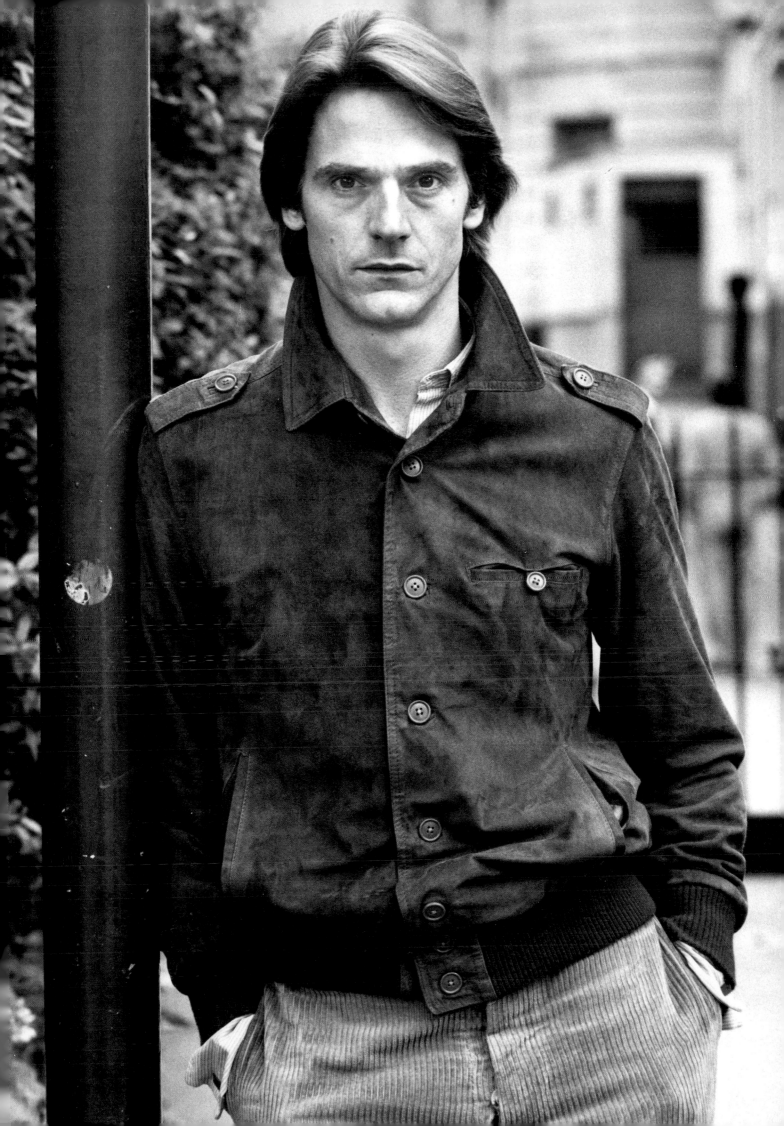

GLENDA JACKSON

Glenda Jackson can be as challenging to her audience as she is to herself, and that is saying a great deal. On this occasion she was touring Eugene O'Neill's five-hour epic Strange Interlude *round the provinces, preparing to battle it into the West End and on to Broadway - which she did. She was asked if there was something defiant about her current working process. 'There may well be an element of truth in that. I am concerned that we are creating a kind of subsidized audience for theatre in England. They go to the National and the RSC, smugly think they are doing the right thing by being in the right place and feel they have fulfilled their function just by turning up. That does not suit me at all.'*

DEREK JACOBI

When Derek Jacobi played Richard II, *Sir John Gielgud sent a signed copy of the script with the message: 'To a worthy successor in a wonderful part.' As the finest verse-speaker of his generation, Jacobi is seen to be taking over the mantle of Gielgud. Jacobi said on the comparisons with Gielgud: 'It is very flattering, but something I don't take too seriously. I suppose my affinity with Gielgud is a vocal one and a gentleness which is in contrast with the macho acting of someone like Sir Laurence.'*

DANNY KAYE

Danny Kaye, born David Daniel Kaminsky,
could not read a note of music, but that did not
prevent him extending his entertainer's career into
conducting - which placed him on the podium in
front of most of the great orchestras of the world.
He once cued the violin section of the New York
Philharmonic with a kick of the left leg and conducted
the 'Flight of the Bumblebee' with a flyswatter.
When asked about his lack of musical knowledge,
he replied: 'You can either fake it or make them
laugh. I'm careful, I do both - or try to.'

DEBORAH KERR

The cool and classy Miss Deborah Kerr had not made a film for fifteen years when she returned to England in the mid-1980s to involve herself with a new generation of movie-makers. From all the film success of the past, it is probably that one famous scene of her rolling in the Pacific surf with Burt Lancaster in From Here to Eternity *for which she will be best remembered. She giggles decorously at the memory now. 'It didn't seem at all shocking to do at the time, but it does seem to stick in people's minds. I think it was far more erotic seeing two people - she taking her skirt off and he taking his trousers off - without any of the things which go on in films today. It is much more effective if you leave some things to people's imagination.'*

BURT LANCASTER

When Visconti directed Burt Lancaster in
The Leopard *he described him like this: 'The most*
mysterious man I've ever met.' The man who
started out as a circus performer has a surface
courtliness which can be punctuated under working
conditions by a restless inconsideration for others,
which seems to spell a sense of dissatisfaction.
He offered a hint, but it was difficult to know how
seriously it should be taken. He says his one
ambition in life was to be an opera singer: 'Ever since
I sang in the church choir as a boy that was my
main thought. Then my voice broke and I've spent
the rest of my life searching for it.'

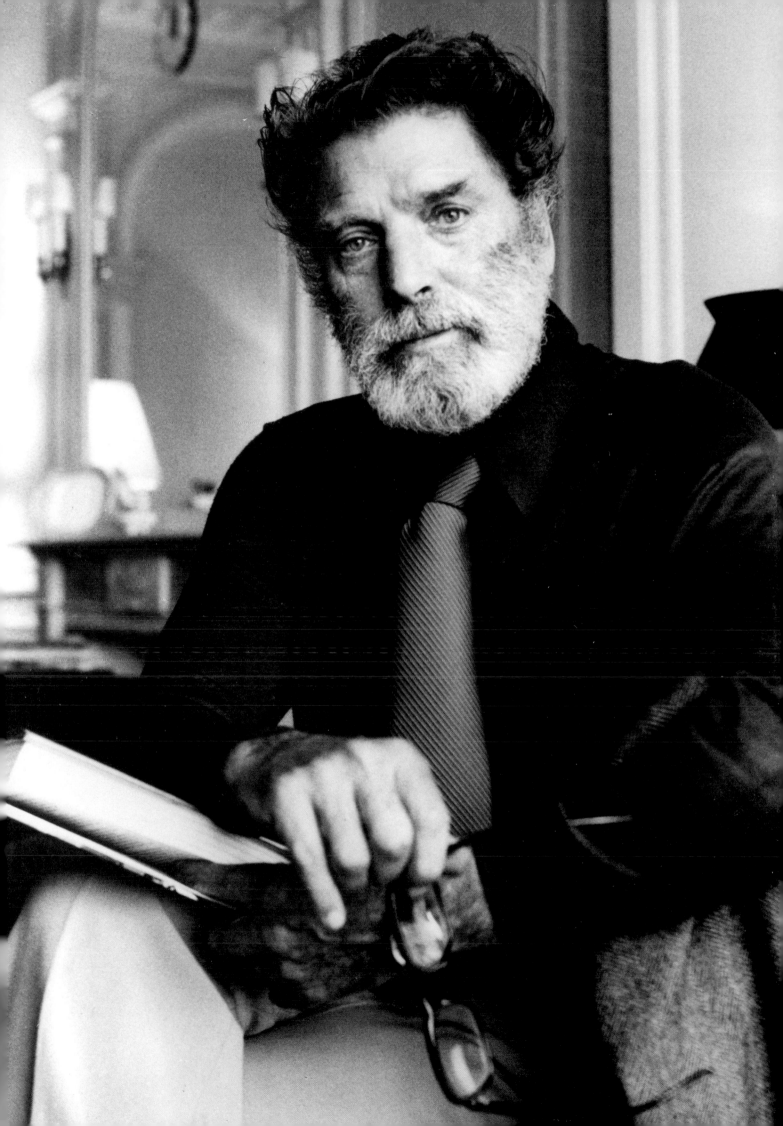

DAVID LEAN

David Lean is a man of total conviction. He makes films on the grand scale and makes no apology for their epic vastness. 'I would rather make one good picture in four years than three in the same time. I'm not interested in drawing-room comedies or murder mysteries. Studios bore me. I like travelling. I like working in rather remote atmospheres and locations. The best year of my life was in the desert on Lawrence of Arabia. That was really exciting.'

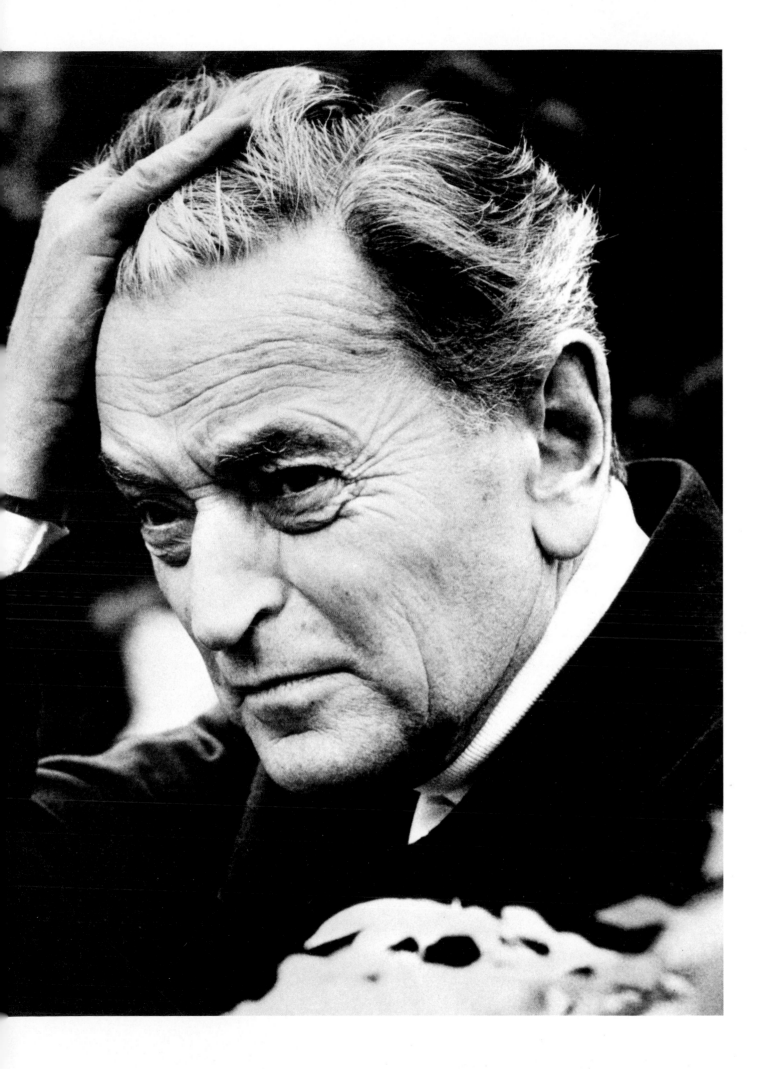

JACK LEMMON

On the eve of his stage debut in London as one of the great tragic figures of American drama, Jack Lemmon talked about a few troubles of his own. Hollywood's Mr Nice Guy (and he is) was about to open in Eugene O'Neill's Long Day's Journey Into Night *playing James Tyrone, the flawed father figure of a family riven by drink, drugs, sickness and endemic meanness. Lemmon talked about the turbulence in his own life, which mostly concerned the bottle. 'I had to quit drinking two or three years ago. I was never a falling down drunk, but I did have a problem. I was near to being an alcoholic. I took the decision to quit and suddenly my whole body felt different. The only thing I miss now is the glass of wine with dinner.'*

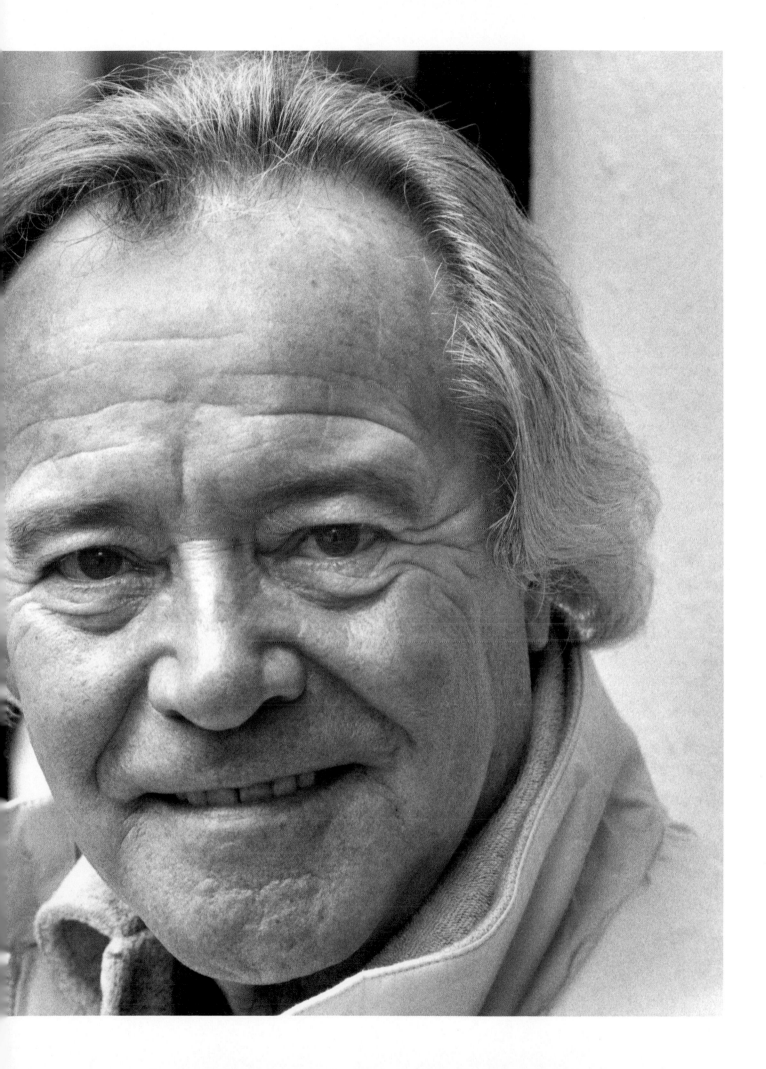

NATALIA MAKAROVA

It was in London in 1970 that Natalia Makarova defected to the West, when she abruptly departed from a Kirov Ballet tour to Britain; it took another eighteen years for her to be allowed to rejoin her home ensemble when they returned to London on a post-glasnost visit. In the meantime she had become the world's prima ballerina assoluta of the post-Fonteyn years. It was an emotional moment for her to be reunited with her Kirov colleagues in a performance to be televised live, permission from Moscow having arrived less than twenty-four hours before the event. It was this photograph by Roy Jones which accompanied the announcement of the event. It has always been her favourite.

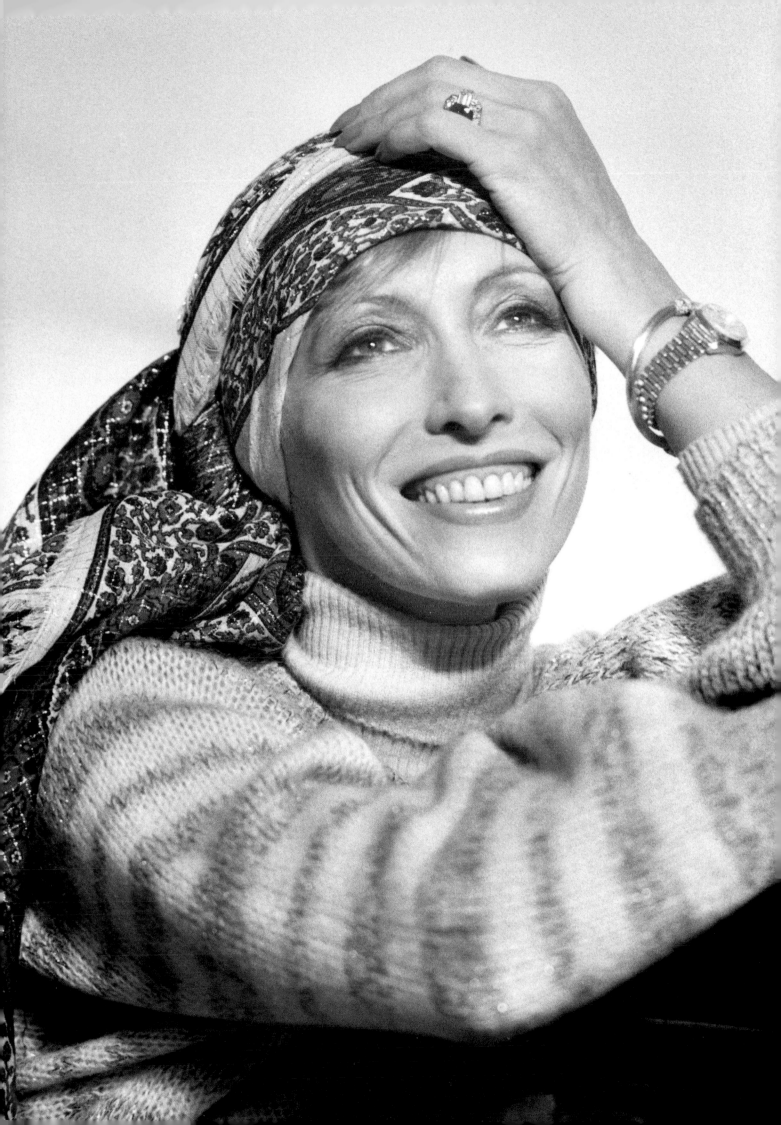

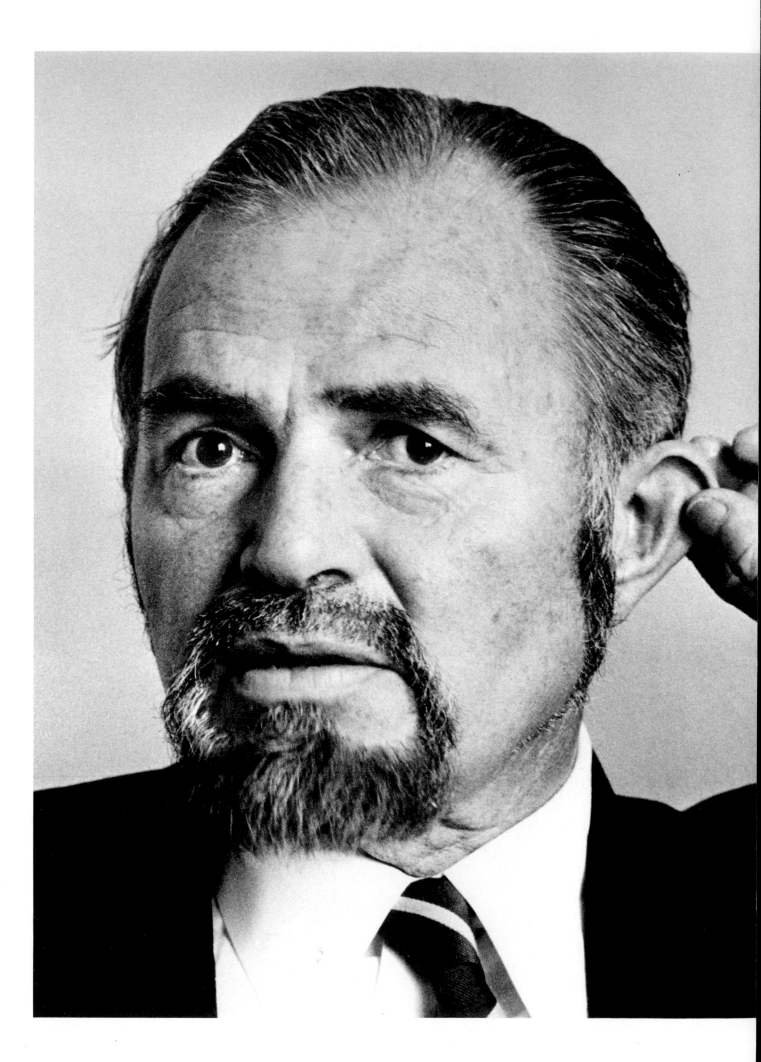

JAMES MASON

James Mason's career divided itself into three stages. There were the early years in England as the sardonic, brutal villain in lurid costume films like Fanny By Gaslight *and* The Wicked Lady, *then twenty years in Hollywood which included* Lolita, The Desert Fox *and* Julius Caesar, *followed by the international career he pursued from his home in Switzerland. In his later years, he saw the two decades in Hollywood as an extended period of failure. 'I started off with five duds, five bad pictures in a row. There were some interesting hits, but I went there because I had set my sights on making myself an acceptable Hollywood leading man. Sadly, it didn't work out that way so I came back to Europe.'*

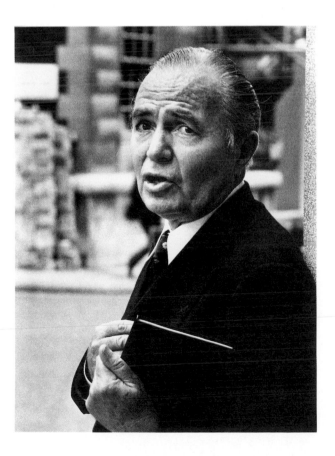

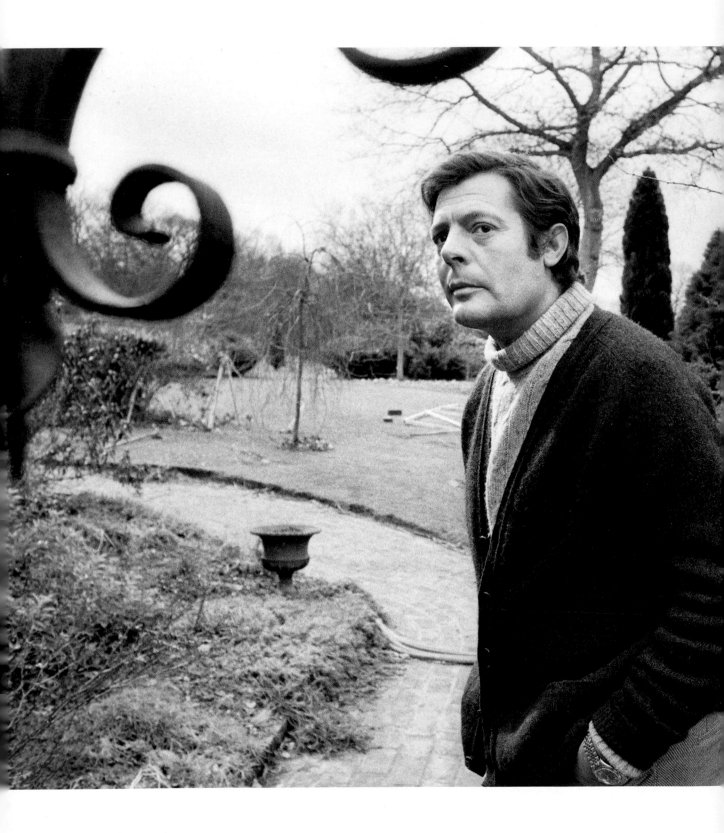

MARCELLO MASTROIANNI

The wiry dark hair may be tinged with grey, but the bedroom eyes, seductively fractured Italian accent and worldly savoir-faire have lost none of their appeal. It is easy to see why MM became one of the world's most romantic figures – as Catherine Deneuve, Faye Dunaway and Ursula Andress would testify – but it tends to cloud his achievement as an actor, the man Fellini rated as the best actor in Italy. Mastroianni publicly is amused by his image as a sex symbol. 'In my private life if you say I am a sex symbol to my family they will laugh at you. The important thing is to exalt the friendships which have come your way. These are the sentiments which are most valuable.'

WALTER MATTHAU

The lugubrious-featured Mr Matthau had enjoyed a twenty-year career as a character actor on Broadway before the film The Odd Couple *catapulted him to stardom and released the gift for comedy which had largely thus far lain dormant. He had a different view of that changeover period. 'The style of the audiences changed about that time. They became interested in the anti-hero. They didn't want their heroes too beautiful any more so the pretty guys were relegated to the character parts. That put me on the winning side, thank God. It would have been murder to have been handsome and beautiful and neglected.'*

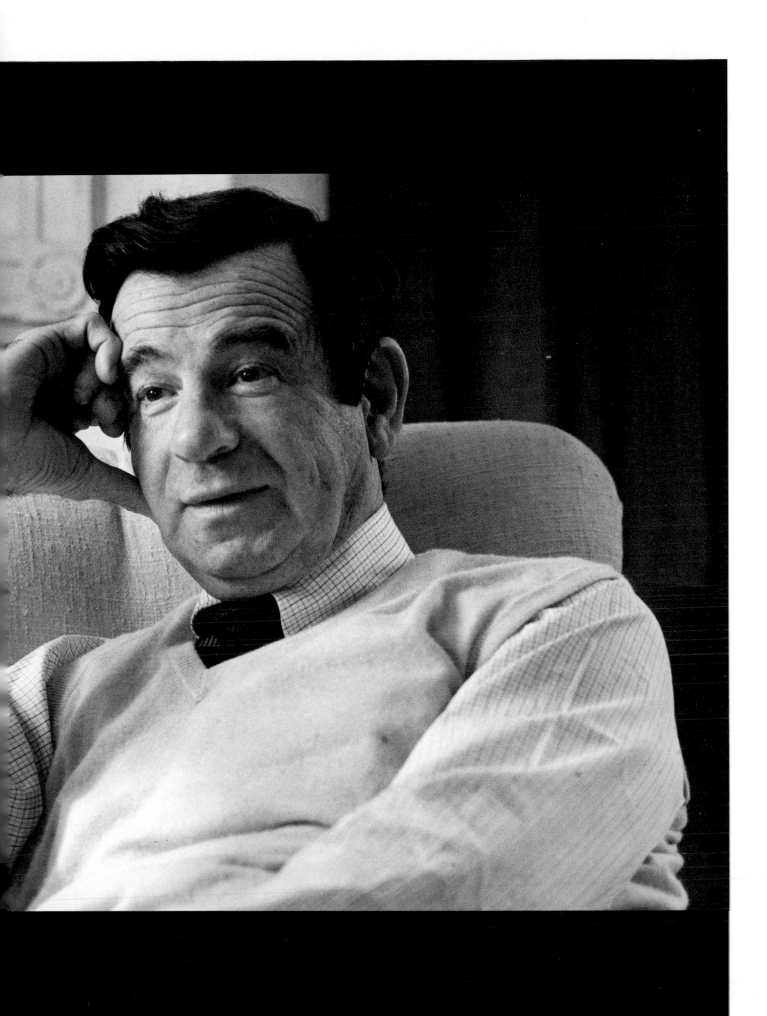

IAN MCKELLEN

Failure does not often touch the career of Ian McKellen, but a setback on Broadway sent him off to a success of a quite unexpected and rare kind. He was booked to play Michael Frayn's Wild Honey *in New York for a year, but the show closed after a month. He decided to tour his one-man show* Acting Shakespeare *round the States and, such was the hunger for a respected English actor demonstrating the art of the Bard, he made an awful lot of money. 'I'd be embarrassed to tell you how much.' He returned to England intending not to work for a while until a friend told him that a projected AIDS hospice was foundering for lack of cash. He decided to run a charity season of* Acting Shakespeare *in the West End, when he even went round the audience with a collecting bucket. Single-handedly he raised £500,000.*

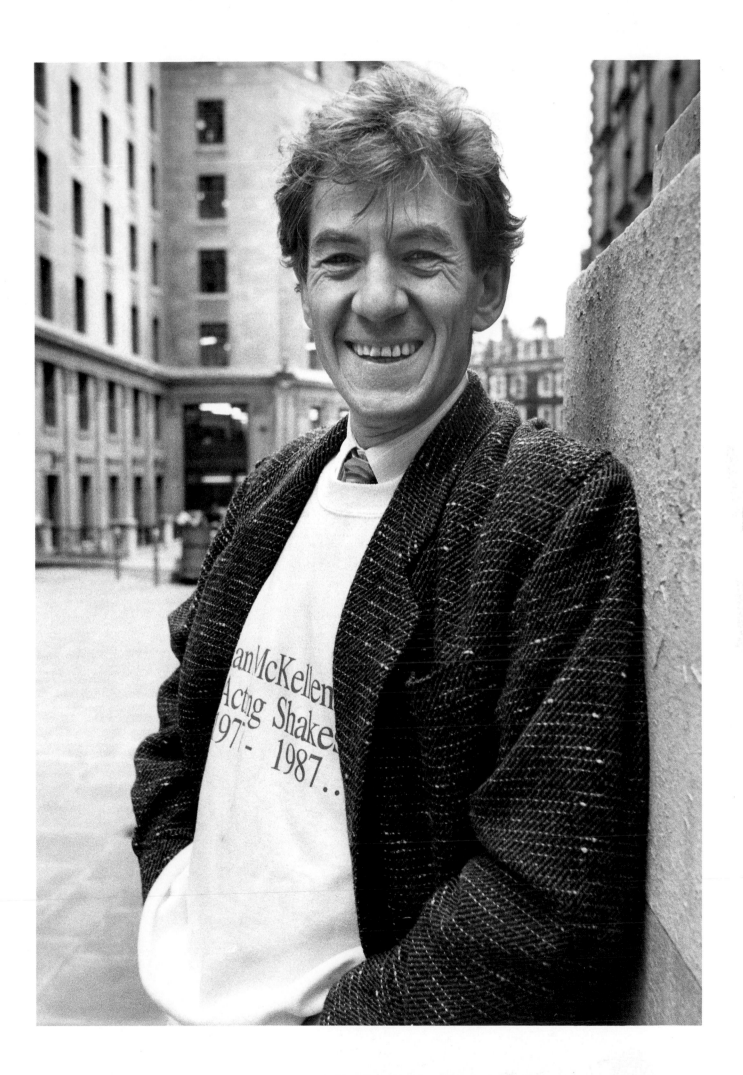

SIR YEHUDI MENUHIN

*Yehudi Menuhin was wearing a bright red kimono
and carpet slippers having just stepped off a plane
after a phone call foreshortened his holiday by four
days. The phone call had been from Prince Charles
inviting the violinist to play at the Prince's twenty-
first birthday party at Buckingham Palace. The
Prince had prepared the musical programme himself.
Menuhin said: 'He took pains over each item.
It is his choice and I think he has shown a discreet
wisdom. He has a tremendous passion for music
and is a quite remarkable young man.'*

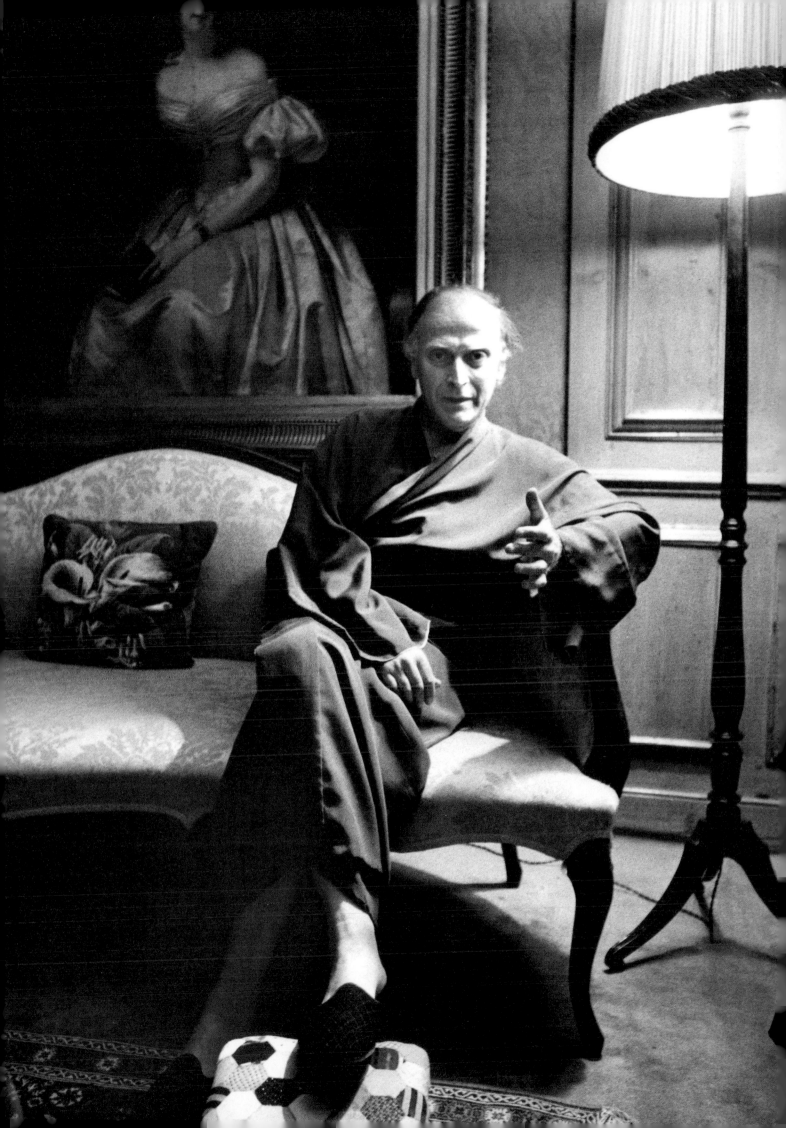

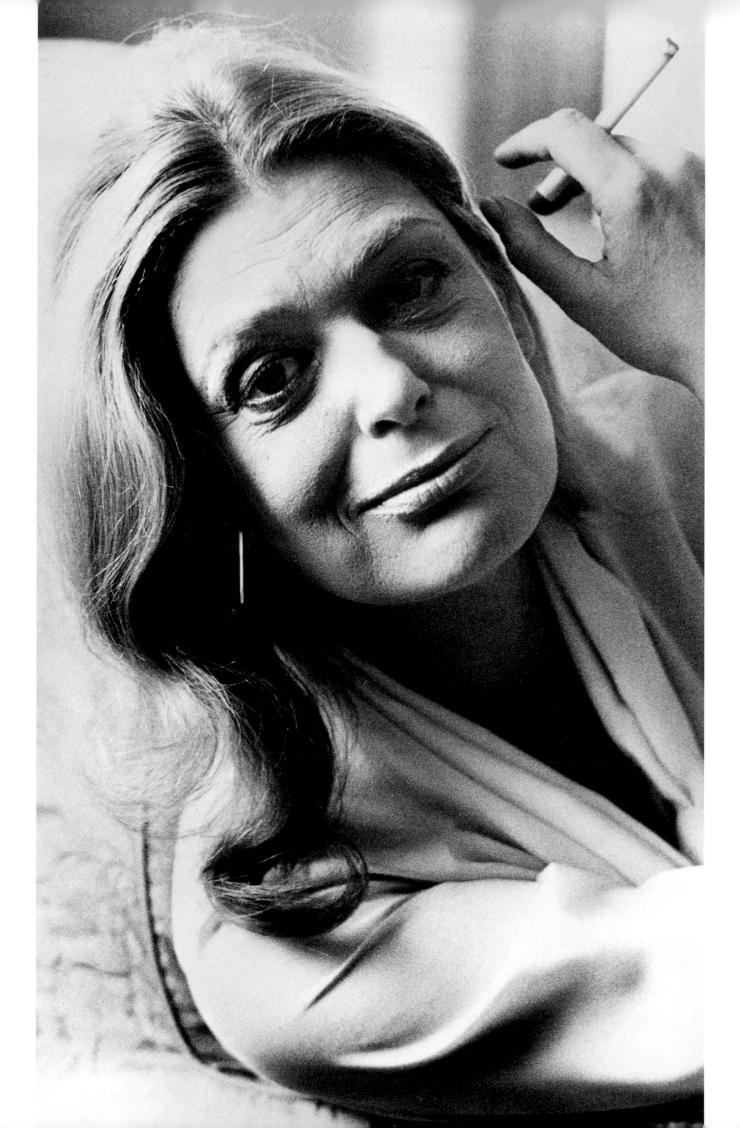

MELINA MERCOURI

When Melina Mercouri played Ilya, the golden-hearted tart from Piraeus, she not only introduced herself to international film audiences but paved the way for her political career in Greece. Her father was an MP and her grandfather had been Mayor of Athens, but it was while filming Never on Sunday *amid the poverty of the Perama district that she determined to stand for Parliament herself.*
'The souvenir of Never on Sunday *is diffused with sunlight yet we had our share of shadow. To see a man beg for work is a painful experience. We saw it every day, at home, in the restaurants, in the streets.'*
Miss Mercouri took Perama as her constituency and launched her political career from there.

ARTHUR MILLER

No interview with Arthur Miller can take place without mentioning Marilyn Monroe. An hour's discussion with America's leading living dramatist on all aspects of theatre was bound to end up on a more personal note about his former wife. He was ready for it. 'Yes, it was terrible that her life was so short. She was a victim of her childhood and the assault committed on her then. It was the burden she had to bear and she knew it. You can't account for the appeal and the legend she became. It has to do with mythology. Like all deities, it defies analysis. She existed not so much as an actress - she didn't make that many films - but as a persona. I think in that respect she is probably unique.'

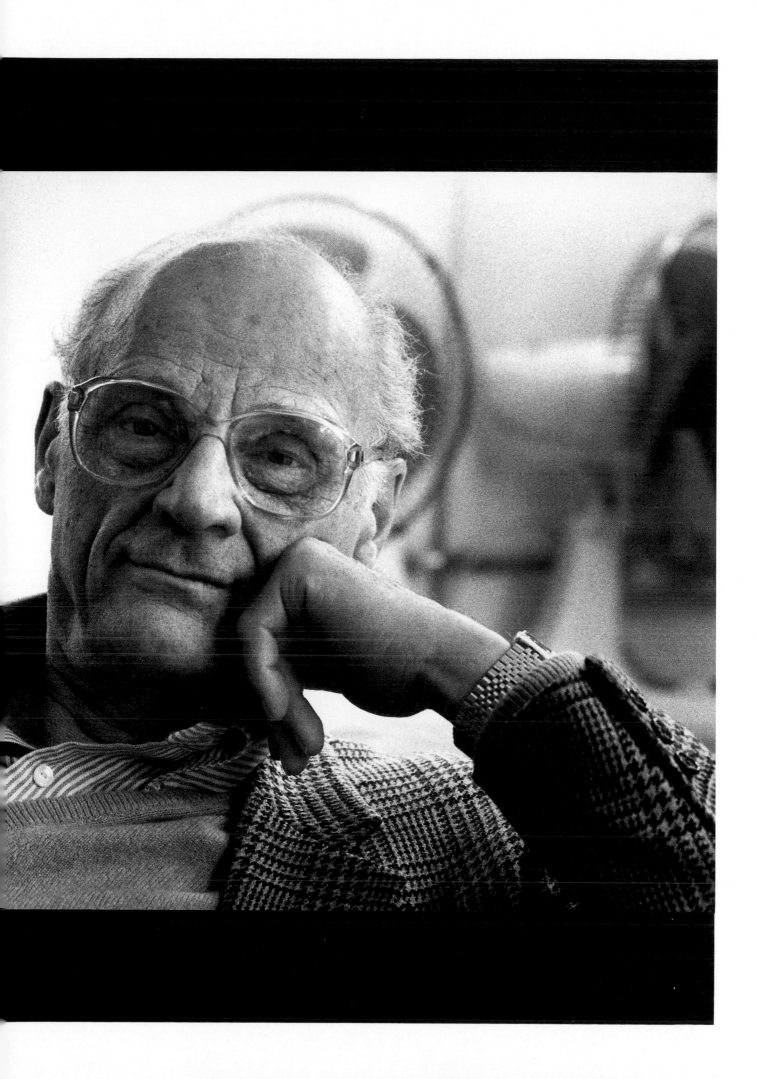

LIZA MINNELLI

Liza Minnelli thrust both hands, palm down, outwards, displaying long, lacquered fingernails. 'See, I've been biting my nails for thirty-nine years and it has taken me until now to stop.' The meeting was just before her fortieth birthday and not long after she left the Betty Ford Clinic. Liza's problem was a combination of valium and white wine and to her immense credit she was prepared to talk about it publicly for the most positive of reasons. 'If there is anyone else out there going through the same thing then I am happy to share my knowledge. That's fine with me.' As far as I am concerned she is not just the outstanding musical artist of her generation - putting aside her gift for film comedy - but a loyal and generous friend.

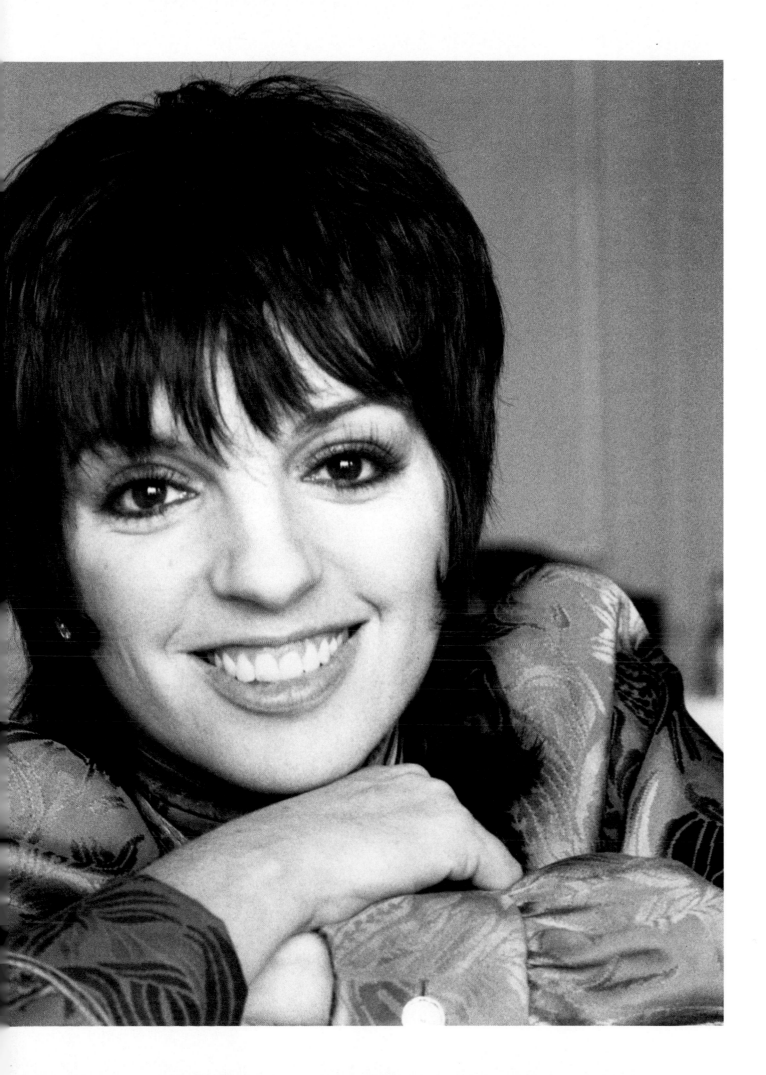

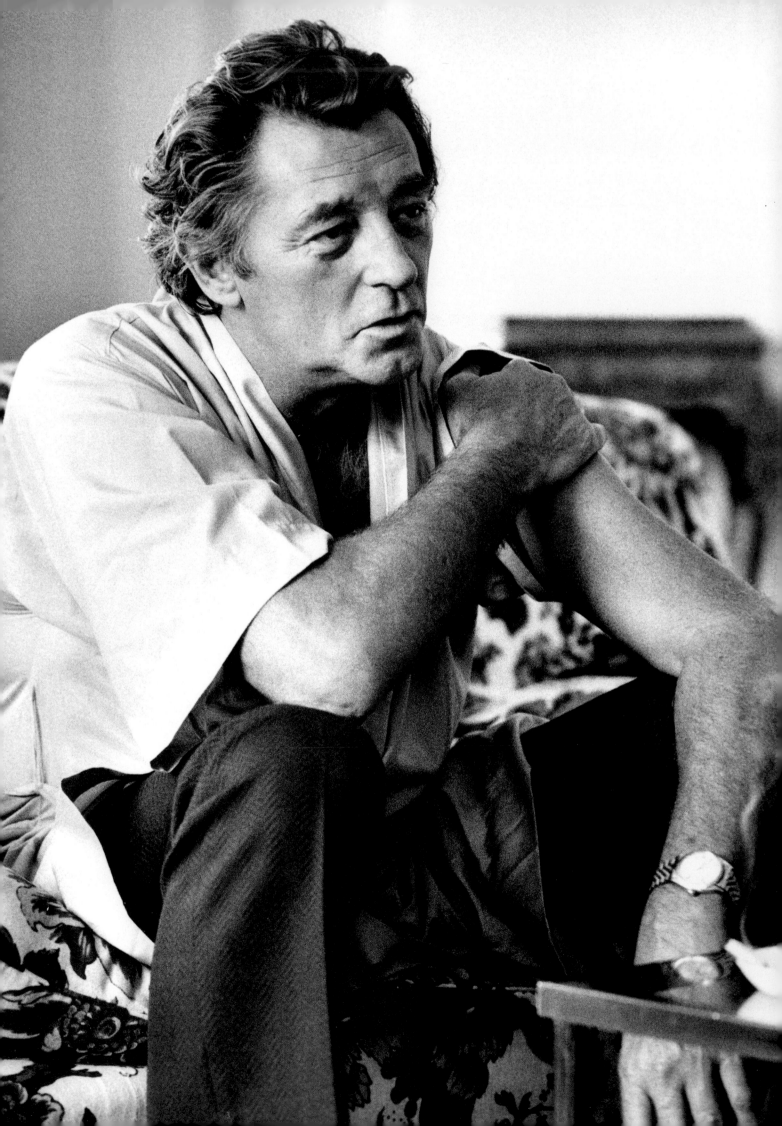

ROBERT MITCHUM

Robert Mitchum hates acting and admits it. The critics accuse him of not acting as he walks through his films: 'Mitchum just seems to point his suit at the other actors.' But Mitchum does not care, especially if he has a glass of tequila in his hand. 'What the hell. It beats working. Listen, when I got to Los Angeles in the early 1940s every loser in the world was there. Mediocrity was the keynote of everything going on. They handed me the blood-stained hat of a guy who'd just fallen off his horse and suddenly I was in the movies, a Hopalong Cassidy movie. I gave hope to the hopeless. If I could make it in movies then anyone could. It was that simple.'

JEANNE MOREAU

For someone as essentially French as Jeanne Moreau, it came as a surprise to learn that her mother was English, a dancer from Oldham. But the star of Jules et Jim, the actress, singer and director who was once described as the Joan of Arc of the boudoir, the sex symbol of the New Wave can sound distinctly French when she philosophizes about her sometimes turbulent life with phrases like: 'Age does not protect you from love, but love to some extent protects you from age.'

RUDOLF NUREYEV

*Rudolf Nureyev was talking on the eve of his
reunion with The Royal Ballet after a five-year
absence which had not been of his choosing. After
all, it was at Covent Garden that he had burst to
stardom in the West after his defection from the
Soviet Union. He is not a sentimentalist, if he causes
controversy he rarely discusses it, but he is a Tartar
and it showed at this meeting. 'They (Royal Ballet)
give me kick on the arse. How else do I explain it.
Yes, of course, I feel badly about it My God,
after dancing sixteen years with Royal Ballet they
abandon me. All my life I make it my rule not to
feel emotion. In my life I learn never to expect
anything for nothing. I just go on. I just keep going.
But now I must confess my rules are broken.
One by one the dancers here come to me and say
they are pleased I am back and express their love.
This week I feel I am very full of the sentiment.'*

JOHN OSBORNE

What happens when the original Angry Young Man of British theatre grows older? He moves away from London, first to Kent then to the more rural shires of England, but he does not lose the laser-like perceptions of the events and establishments around him which draw his greatest disapproval. This time it happened to be the Royal Court Theatre, where he famously began his writing career. On the twenty-fifth anniversary of the theatre company he helped to found there he had this to say: 'There is no overall taste or imagination there. It is the sheer mediocrity of everything they do which I can't stand. I went to see a play there recently just to keep in touch. It was dull and pretentious, but mainly just dull. It also had the mistaken belief it was treading new ground. Frankly, I'd rather go for a pint of beer.'

PETER O'TOOLE

This splendidly madcap Irishman was the play-
boy of the Western world and beyond for several
decades and survived the booze, the broads and even
major surgery to calm down to a quieter life when
he put aside the bottle and concentrated on an
increasingly theatrical life rather than the movies.
On the eve of his risk-taking debut on Broadway,
he had survival on his mind and gloriously told the
story of how his father kept the Grim Reaper at bay.
'My old man was knocked down by a car. When
they took him to hospital they found he had nine
mortal injuries. He should have been dead nine times
over. When we went to the hospital we found a
form and do you know what it said: "The patient
discharged himself." He managed to die at home.
I like that and I hope it runs in the family.'

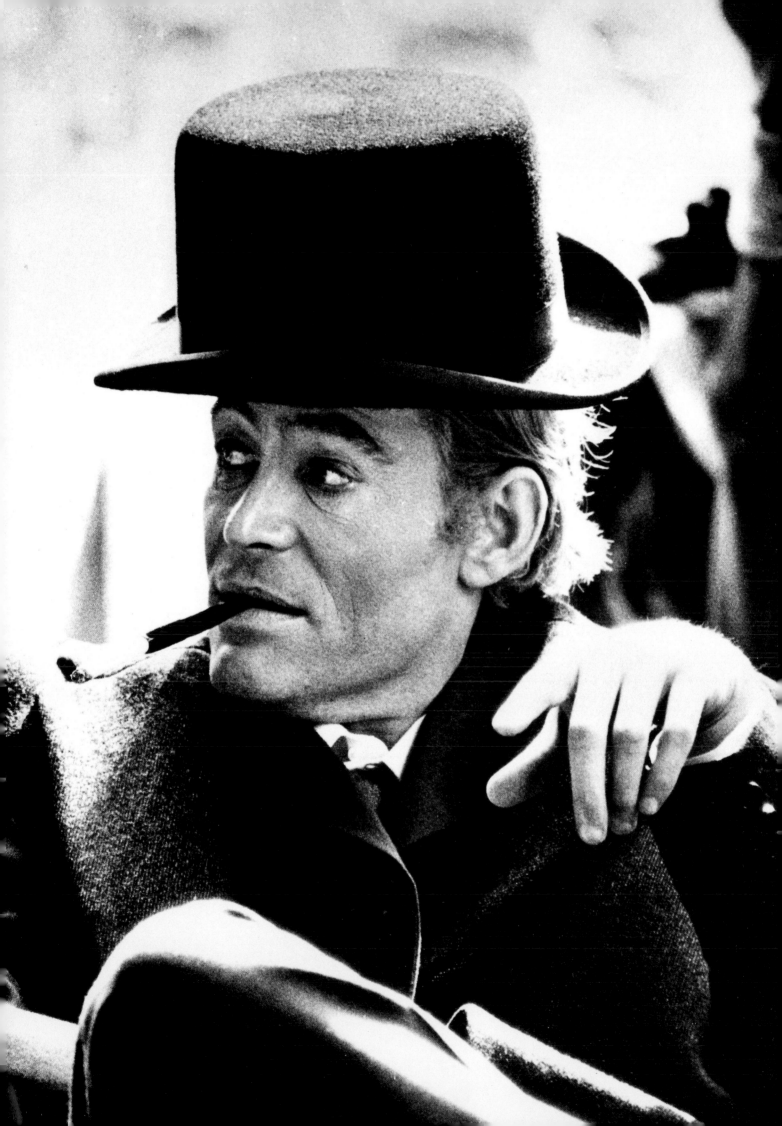

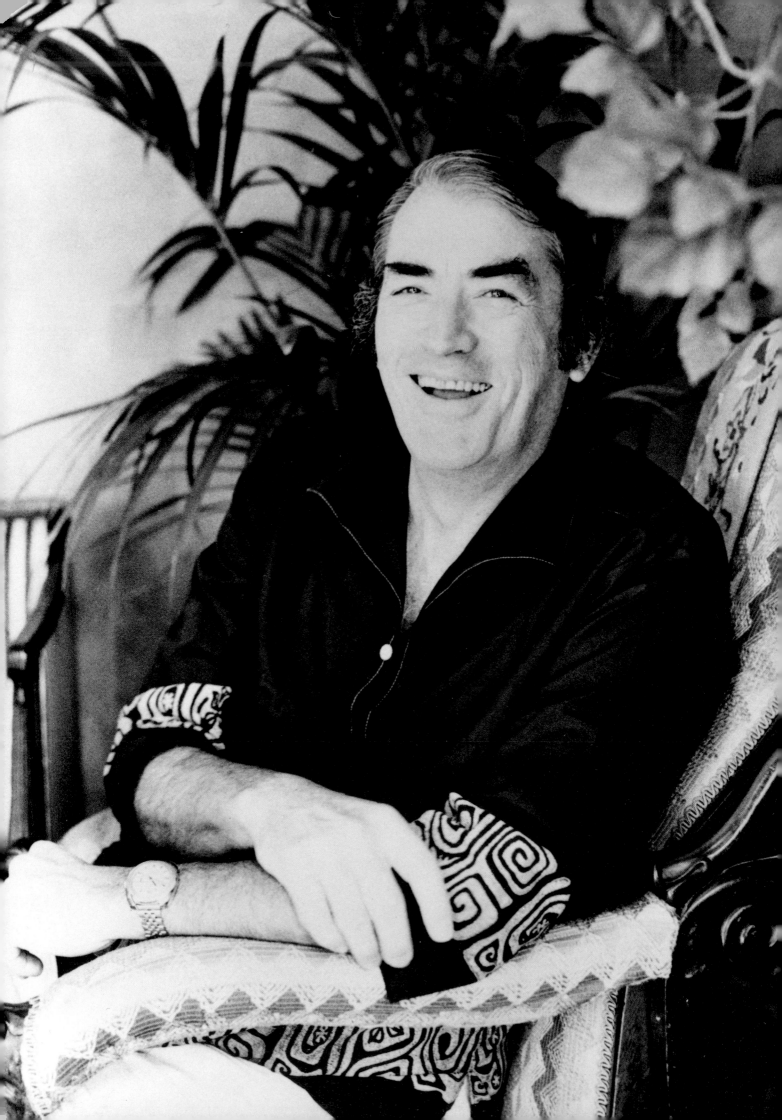

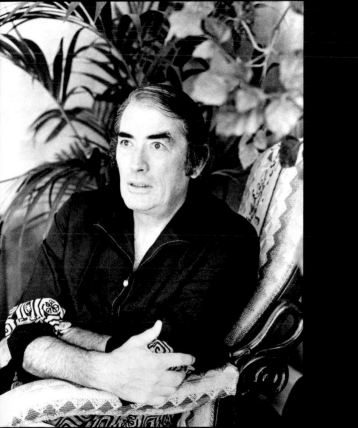

HAROLD PINTER

In the lounge of the mews house he uses as an office Harold Pinter threw open a cupboard and gestured at an undisturbed pile of yellow foolscap pads. 'That's what I write on. One of the great things New York gave me. Yellow pads. I scribble on the pads and look at them, sometimes put them away, but almost invariably tear them up, screw the damn piece of paper up and throw it into the waste-paper bin. There is nothing I would love more than to write another play, but for the moment I can't do it and it is very frustrating.' Since that conversation in 1983 Pinter has produced two one-act plays, but a major full-length play has continued to elude him.

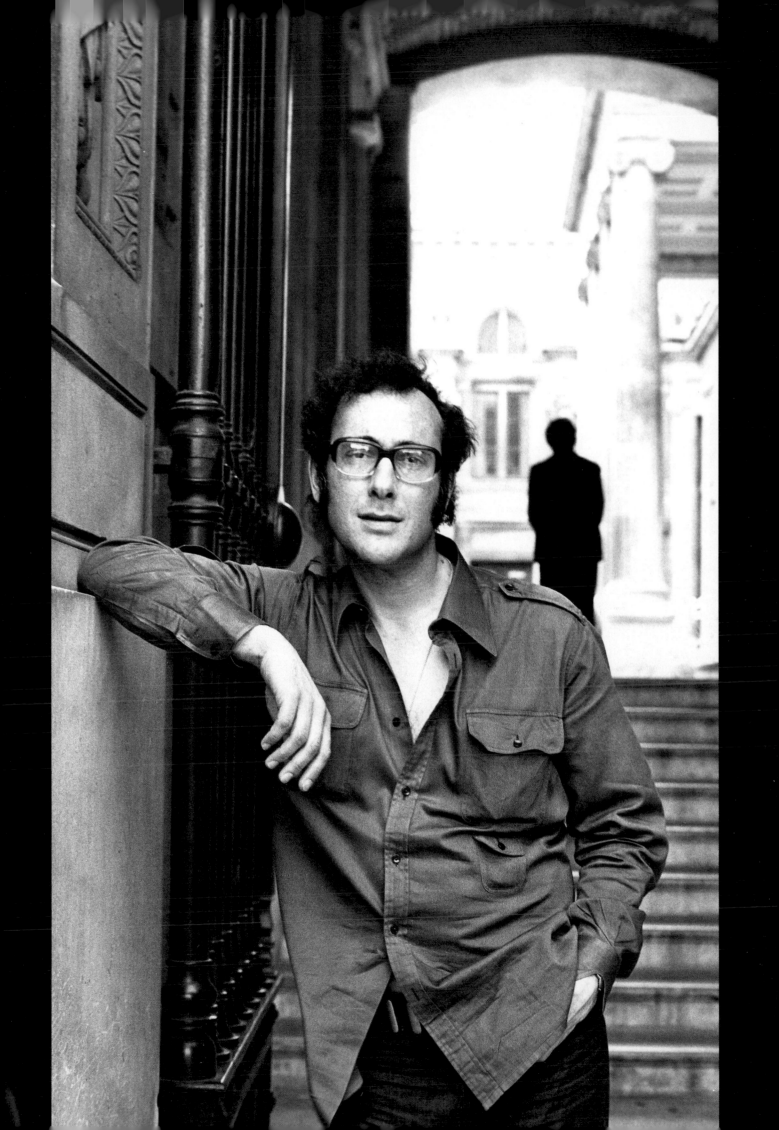

JONATHAN PRYCE

The tall, gaunt figure of Jonathan Pryce is best known abroad for films like The Ploughman's Lunch *and* Brazil, *but at home he is even better known for the edge of danger he brings to his stage performances in shows like* Comedians, *with its pent-up violence,* The Taming of the Shrew *at Stratford when he entered from the audience to tear down the set, and* Hamlet *in which he starred and produced the voice of his dead father in a fit of possession. Are you really dangerous, Mr Pryce? 'No, I'm just a pussycat. I'm a very happy and contented man. But who knows what darkness lurks within us. It's just that I get the chance to work it out on stage - and get paid for it.'*

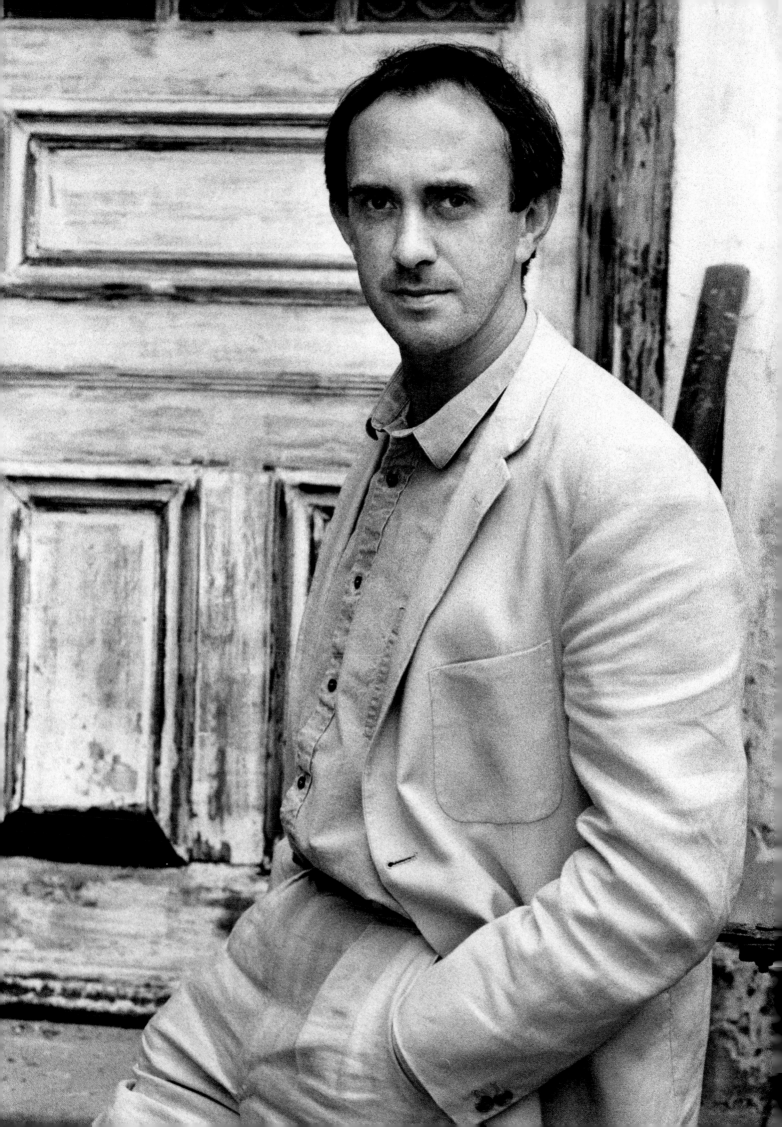

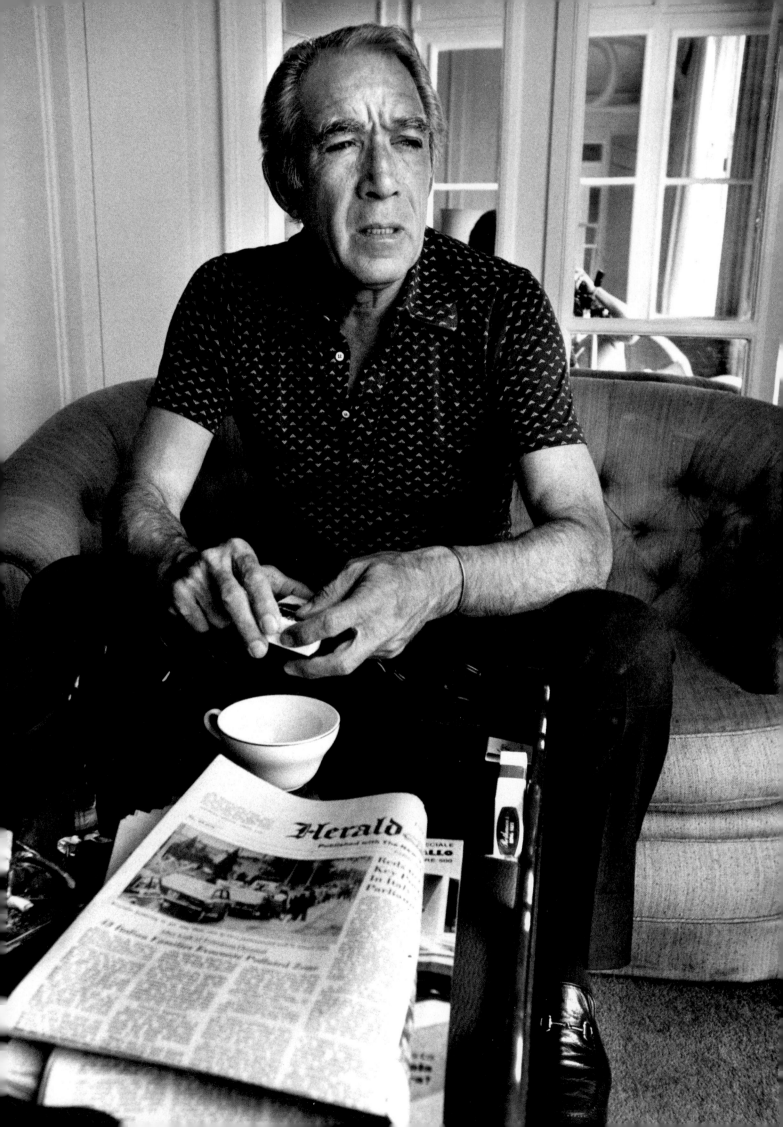

ANTHONY QUINN

With 140 films - including the immortal Zorba the Greek *- and two Oscars to his credit, Anthony Quinn found a new kind of success as author as he entered his sixtieth year. He was acclaimed for his autobiography* The Original Sin, *written as a psychological conversation between himself as adult man and himself as young boy. The sin of the title was not to be able to love himself nor to accept love from others. 'I published because I wanted to show my children that we were not that far apart, that we all had an expectation and need of love. In the course of writing the book I discovered I did not love myself. But I do not need to love myself any more. I have transferred to loving my kids. I identify myself through them.'*

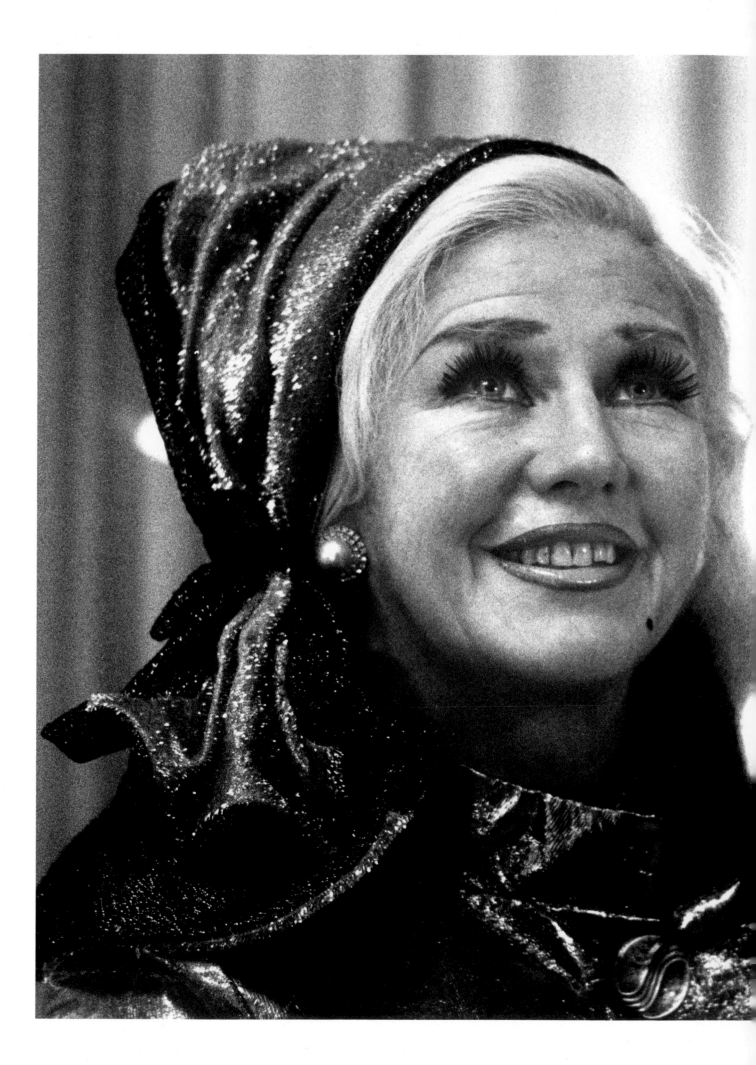

GINGER ROGERS

For all the grace and swirling elegance Ginger Rogers brought to those famous films, the lady herself turned out to have a raucous sense of humour. When she made her London stage debut in Mame *at Drury Lane in 1969, a special dressing-room was built in the wings for her to her own specifications. Swathed in pastel-shaded silks and extremely lowly lit, it contained a small sofa set in its own fabric awning and it was there we sat for an interview. Miss Rogers interrupted the session with a joke she had newly heard. To reinforce the point of humour she leant forward, slapped me on the knee and happened to catch the reflex point: my foot jerked up near her head, and one of the most famous screen faces of the century was just millimetres away from serious damage.*

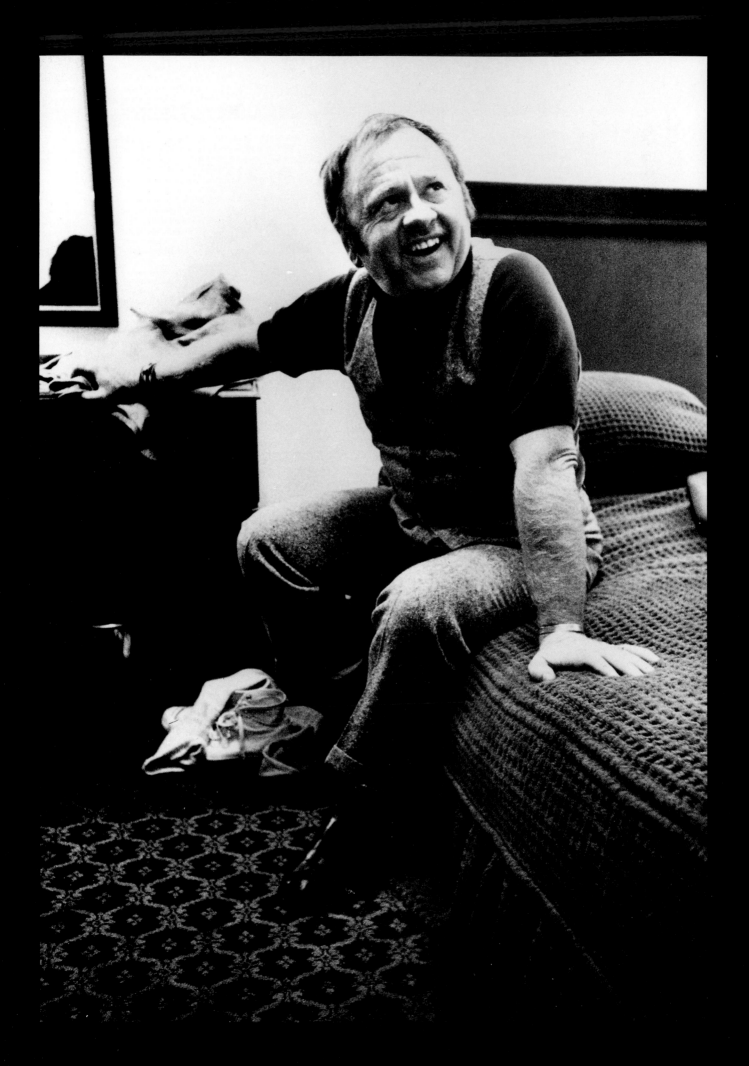

MICKEY ROONEY

Mickey Rooney was an hour late for his morning appointment with Jones, which at least gave Jones the chance to sleep off what he admitted had been a particularly heavy night. When Rooney arrived he spotted the symptoms. 'Not feeling too good, huh? Let me help.' He practically forced Jones on to his knees on the hotel carpet, stood behind him, took his head in both hands and, with a crack that sounded like a pistol shot, savagely twisted it to one side. When he recovered from the shock of the instant treatment, Jones did feel better and the photograph was duly achieved.

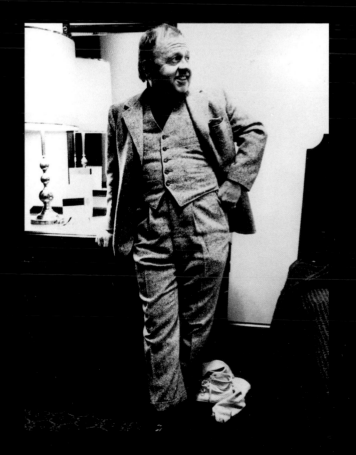

ISABELLA ROSSELLINI

The long-standing affair between Ingrid Bergman and Italian director Roberto Rossellini scandalized Hollywood in the 1950s and the arrival of the daughter of that liaison in major movies caused almost as much fuss. Isabella Rossellini put modelling aside to star in Blue Velvet, a nightmare look at the dark side of small-town America, which was condemned for its scenes of sex and violence. The actress justified her presence in the film by saying: 'I know the mood of the film was sex and violence, but I hoped to find another aspect to it, something beyond the rational. If we are honest we all have some dark side to our nature.' When she was photographed she had just returned from having her shoulder-length, dark hair chopped back to urchin length at the hairdresser's. The image of her mother as Joan of Arc stood in front of the camera.

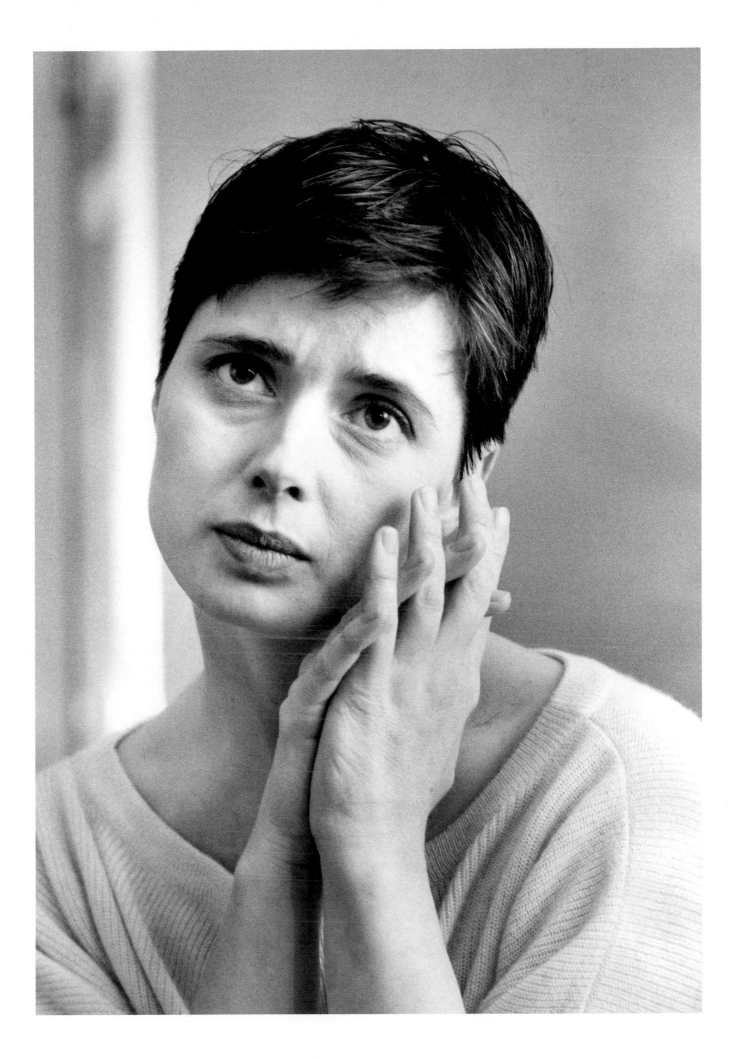

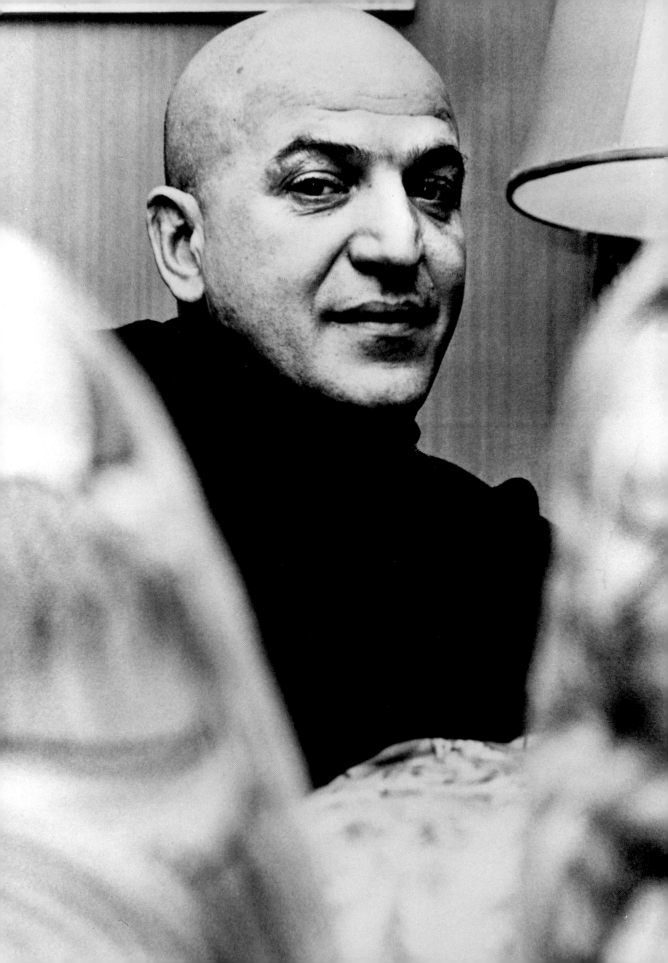

TELLY SAVALAS

He was born Aristotle Savalas, his family called him Telly, but the world came to know him as Kojak, the tough TV cop with the mile-wide streak of street-wise humanity running through him. That humanity is not always evident during a meeting with Mr Savalas. But he does have the grace to tell a story against himself about the day his mother defeated him just when he had presented himself at his toughest. 'I was an amateur boxer and up against a big truckdriver who was none too bright. I gave him a pretty bad beating and the fight was stopped in the second round. As I left the ring up jumps my mother and grabs our hero Telly by the ear. She tells me I'm an animal and slaps me across the face right in front of my friends and the whole neighbourhood.'

GRETA SCACCHI

Pronounce it Skaki, remember she is the daughter of an Italian art dealer and an English ex-Bluebell dancer, and understand this young, independently-minded young lady has a limitless future based on the early success which began with Heat and Dust. After five years of film-making she broke off to play Chekhov on the London stage, saying: 'I've been lucky in finding good films with good directors but I still feel frustrated. With fifty or more people on a set it's a miracle you feel any synchronicity with what's going on. I find the experience very limiting and I'm fed up with it. It comes down to a question of trying to achieve your craft and a film set is really pretty chaotic. I'm ready for a change.' Without doubt she will be back to the movies – with a vengeance.

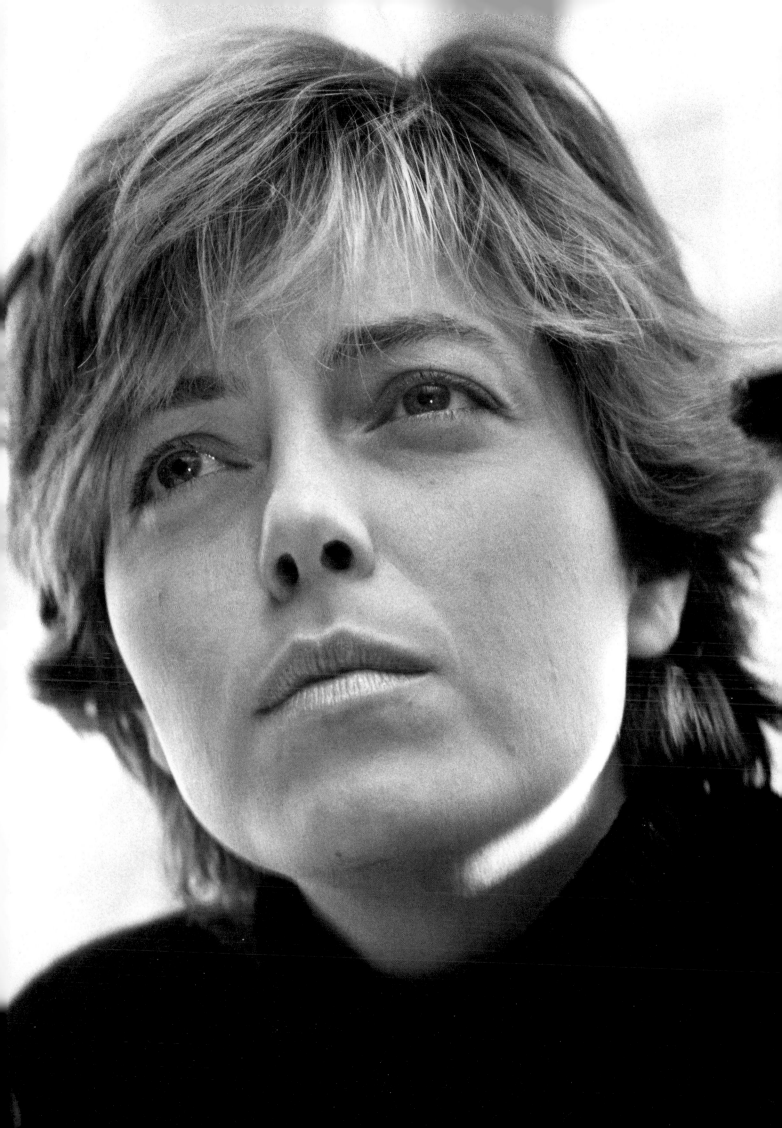

PAUL SCOFIELD

An interview with Paul Scofield seems like an act of intrusion, such is the length he goes to to protect his privacy. His work comes in bursts alternating with lengthy spells at his Sussex home. He is sparing with himself. 'Am I? I may not have done many films, but I don't think I have missed too much in the theatre. At the beginning of my working life I did everything for the sake of experience. But later instead of experience being everything, choice becomes everything. You learn you must not do it unless you want to very deeply.'

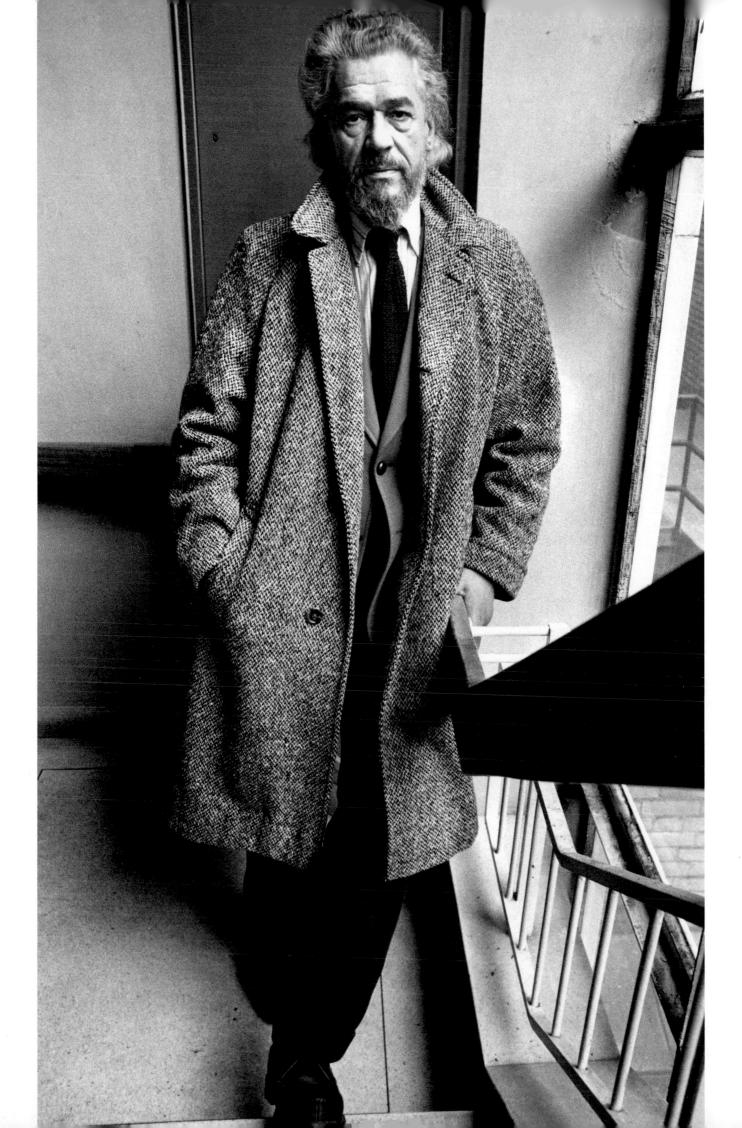

PETER SELLERS

With a low, quick greeting, a few sentences in his well-known Indian accent, Peter Sellers sat down in the silk dressing-gown and brown pyjamas which the role he was filming required and remained polite but unrevealingly muted. The real self was in hiding yet again. This comic genius was subject to wildly swinging changes of mood and suffered unknown insecurities about his own identity. The photograph says it all.

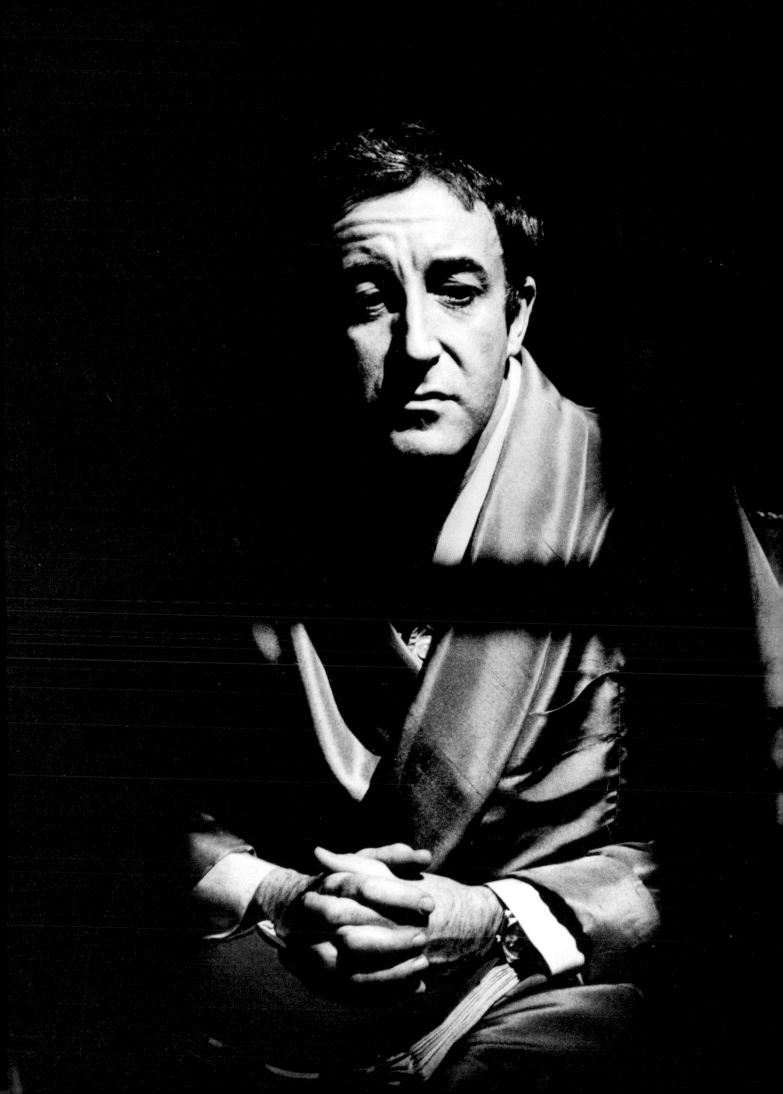

MAGGIE SMITH

She has elevated her own particular brand of stage anxiety, apparent fear and general neuroses into an art form all its own, but endlessly delivers the goods. The angled wrists and taut expression speak volumes of her apparent despair at having to go on stage again. She is the supreme mistress of comic and classic theatre and seems the finest, thoroughbred, high pedigree actress at work today. Yet you can hear her response to that: 'You don't think I'm a horse, dear, do you?' She can also be caring, companionable and downright homely as she was when she opened her Virginia stage success in Stratford, Ontario, and followed her performance by cooking out of saucepans for anyone who cared to turn up. Miss Smith remains a brilliant mystery.

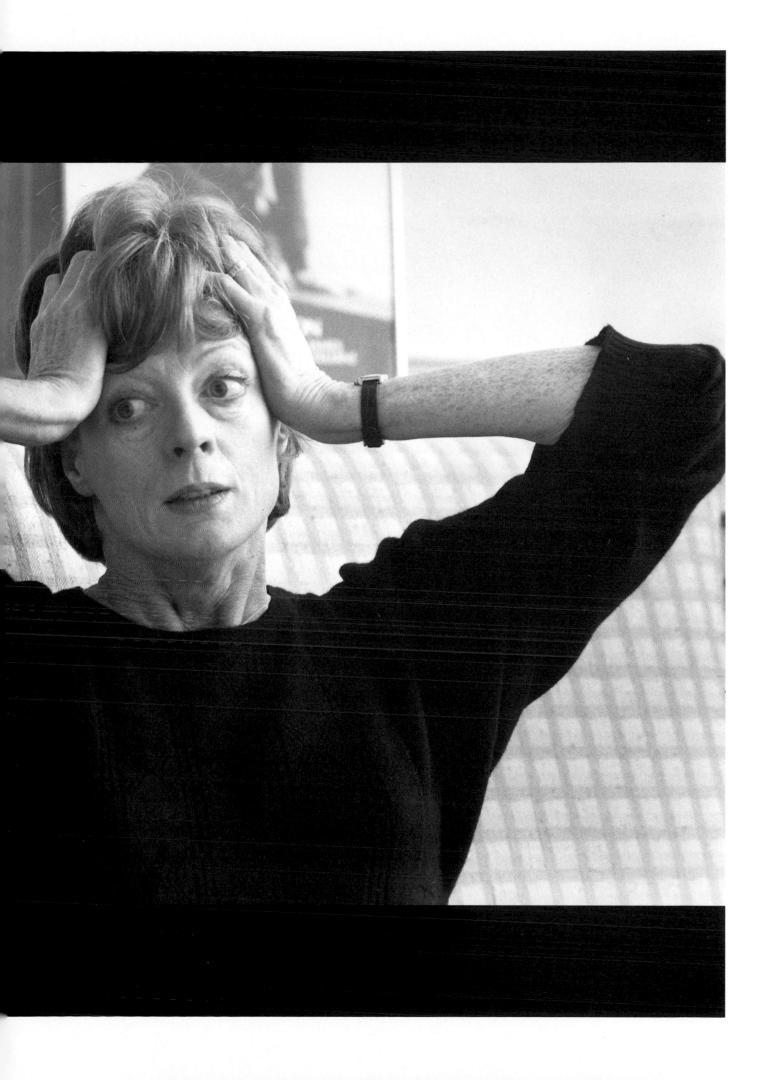

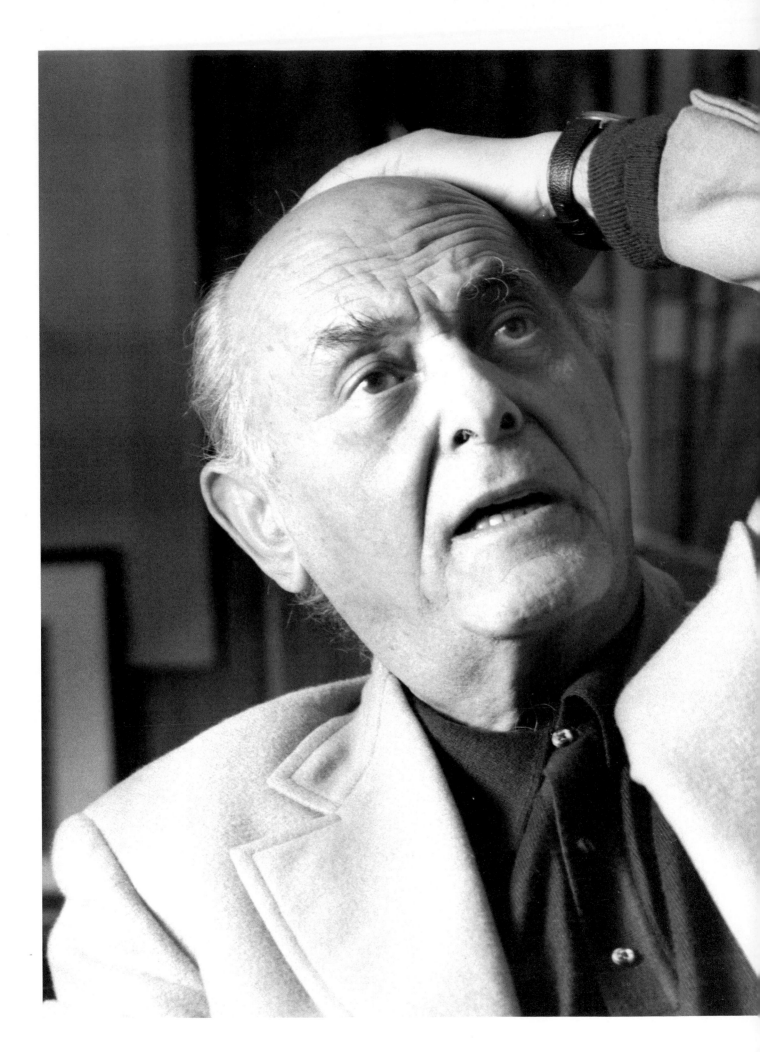

SIR GEORG SOLTI

The effervescent, ever-ebullient conductor Sir Georg Solti takes some persuading to be still, but he approached the nearest he can get to calmness when he talked about the effect his fellow Hungarian, composer Béla Bartók, had on his life during a brief period when Bartók was his teacher in pre-war Budapest. 'First you must understand he was like God to a student like me. He had a Jesus Christ quality of purity and nobility. It was very strange that this man whose music could be like the volcano was very gentle and softly spoken. What he taught me was how to be serious about music. That music is not just a pattern, but that it must be your life. That, I have never forgotten.'

STEPHEN SONDHEIM

Stephen Sondheim's future was set when, after his parents divorced, he came under the influence of Oscar Hammerstein II. 'He was like a surrogate father to me. I was very fortunate as by the time I was in my teens I knew exactly what I wanted to do, thanks to him. If Oscar had been a geologist instead of a lyricist then I guess that's what I would have done.'

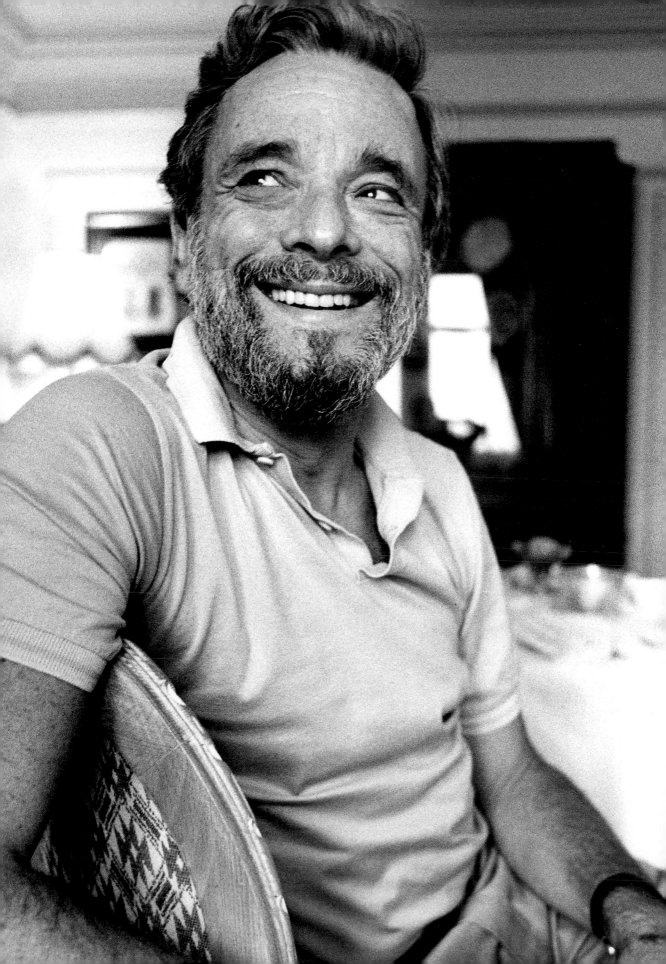

JAMES STEWART

'Waarl . . .' The curious and much mimicked
drawl curled its way round the larynx of James
Stewart as, in his seventy-fifth year, he set off at his
own pace on another memory of the past, this time
about some of the great actresses he had worked with
like Dietrich, Hepburn, Lombard, Kelly, Colbert
and Crawford. Mr Stewart was too much of a
gentleman to go into intimate revelations, but he did
say: 'I guess I got a crush on every one of them while
we were making the film and that made the movie
all the more pleasurable. Some of those love scenes
did not take too much acting. In a scene with Jean
Harlow it was difficult not to respond. I tell you,
when Harlow kissed you, you stayed kissed.'

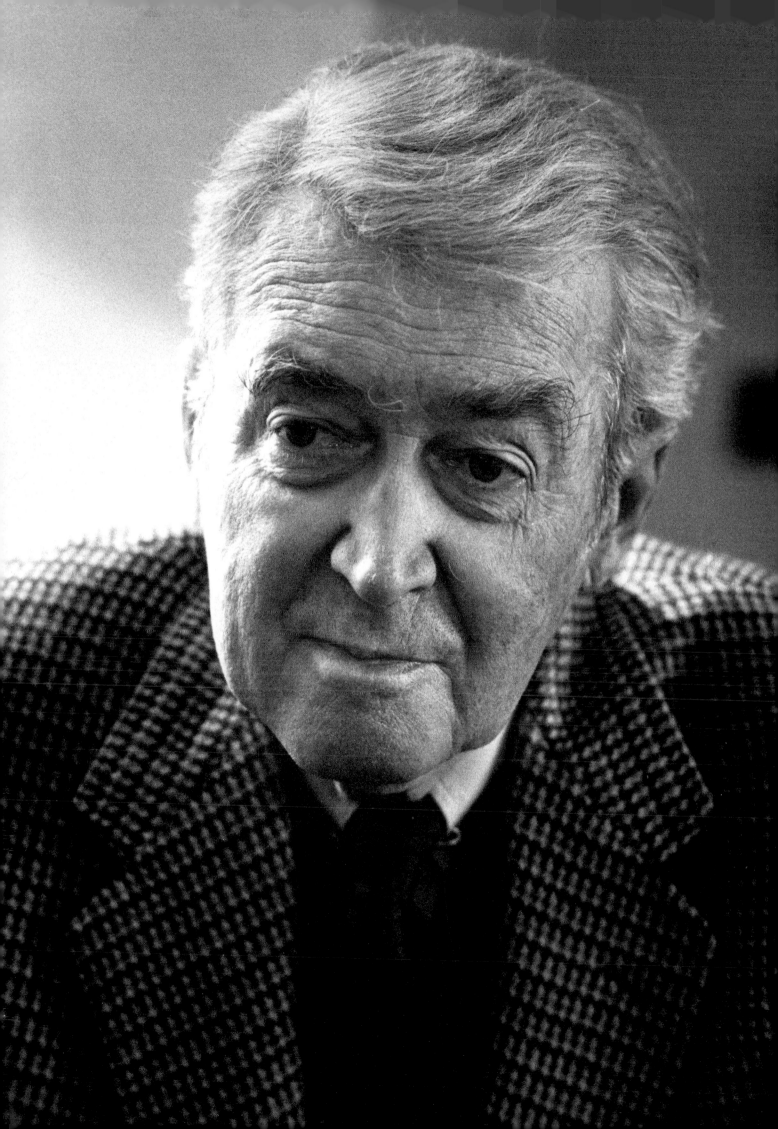

TOM STOPPARD

Tom Stoppard started his career as a newspaper-man and brought the same inventive imagination to his journalism as he did later to his play-writing. On a local paper in Bristol, he was reporter, feature writer, film critic and motoring correspondent – even though he could not drive. 'I spent a lot of time describing the colour of the upholstery.' Then he started reviewing theatre at the Bristol Old Vic and produced a short play himself called Rosencrantz and Guildenstern Are Dead, *which was first staged at an international theatre festival in Berlin. 'I was there with a group of promising playwrights. The English ones all sensibly went on to be novelists and the Americans sensibly went off to make films. I seem to have got stuck.'*

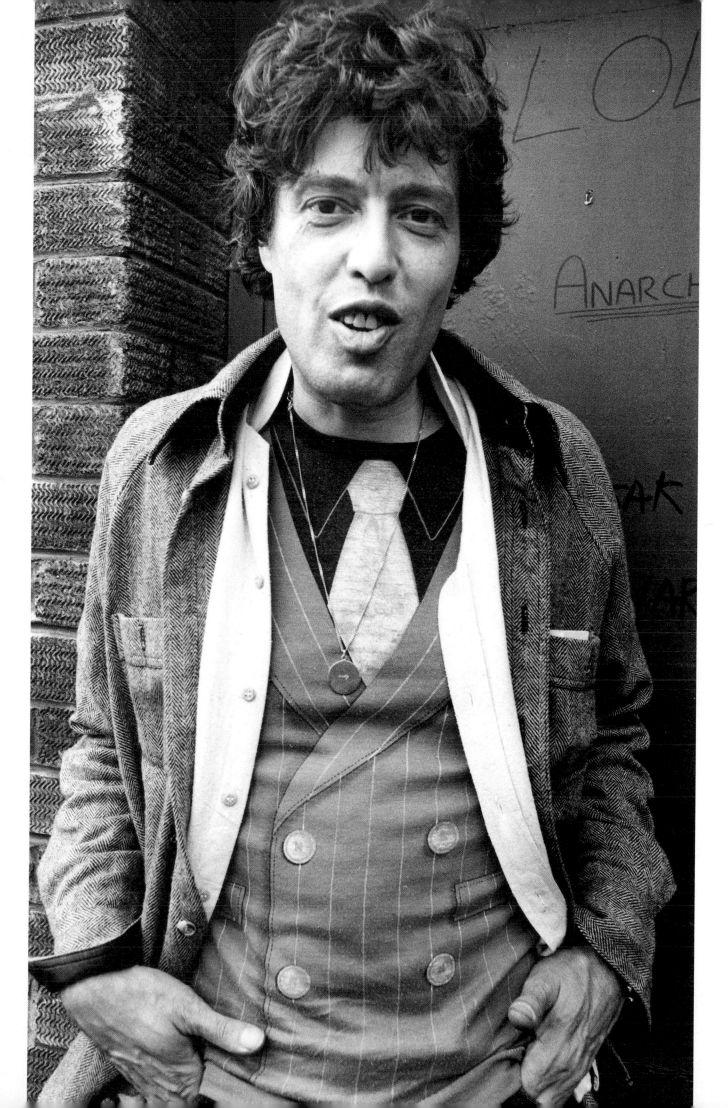

MERYL STREEP

Mary Louise Streep was born to parents of Dutch origin in a middle-class section of New Jersey and was the ugly duckling of the neighbourhood school with glasses and braces on her teeth. 'I looked so odd the new kids thought I was a teacher. It was bizarre.' She fell into acting at her Ivy League college and was discovered by Joe Papp. 'They said I was good, but it seemed no way to conduct your life. Now I have confidence in my craft, in what I do. I just want to make the characters I play as truthful as possible. I don't give a damn about the other sides of the business apart from getting the performance right.'

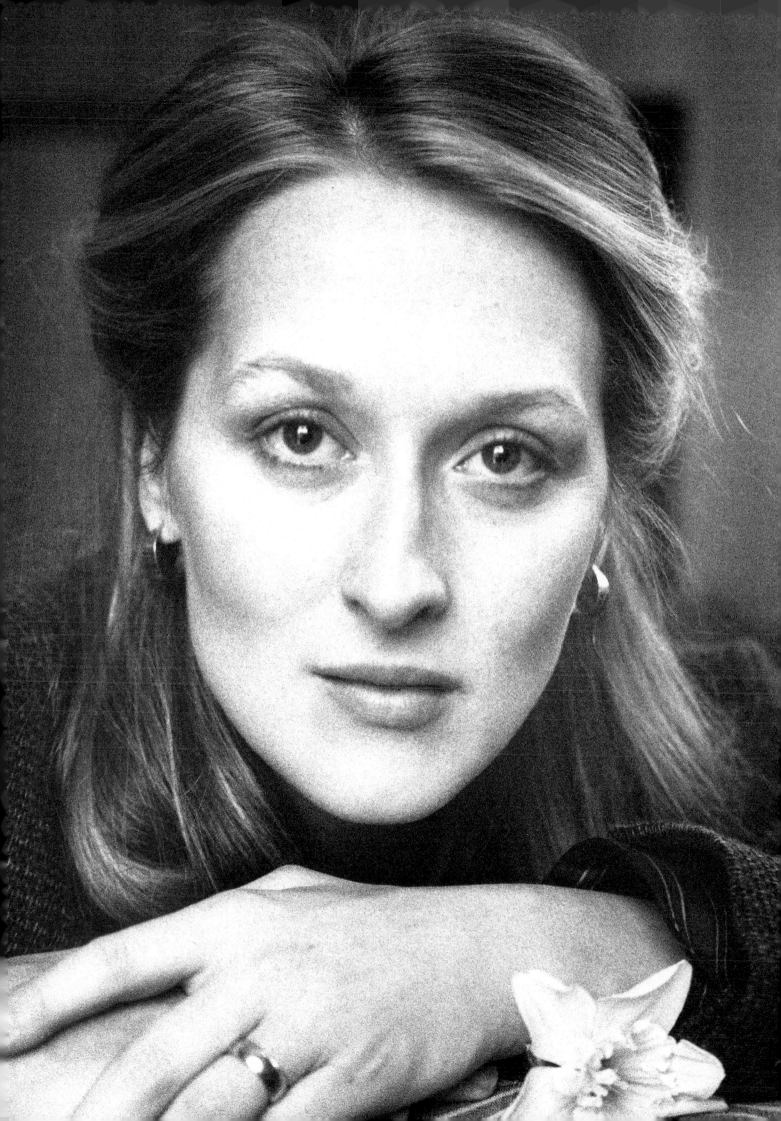

SIR MICHAEL TIPPETT

He was once a Communist Party member and a conscientious objector during the war, who went to Wormwood Scrubs prison where he took over as conductor of the prison orchestra, a post previously held by Ivor Novello. He combines the respect of the music establishment with a youthful cult following in the United States. He started visiting America only in his later years and was surprised to find students wearing T-shirts with the slogan 'Turn on to Tippett'. On another occasion he overheard a youngster passing a record of Tippett's first opera, The Midsummer Marriage, to a friend with the words, 'This will burn your brains out.' Tippett was delighted.

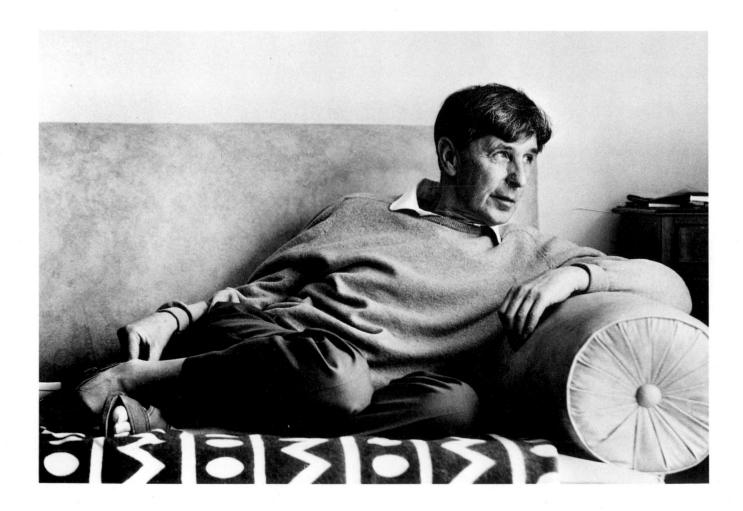

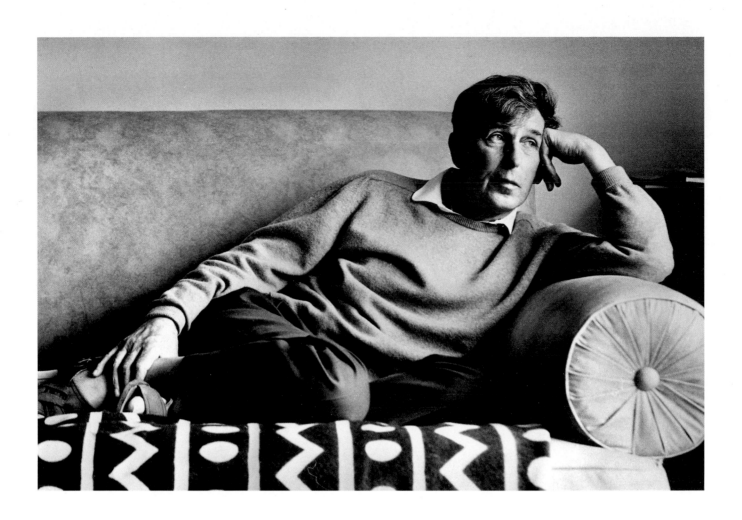

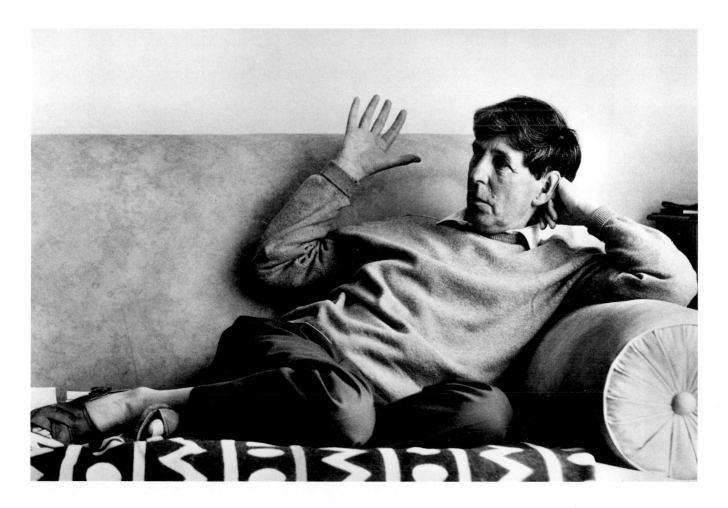

JULIE WALTERS

Julie Walters knew the waiter was listening as he poured morning coffee in a rather formal hotel lounge, but she persisted with her story: 'It's not very easy going to bed with someone you don't know. I've only done it a few times and the best thing to do is have a quick cuddle and get on with it. But it's difficult when you know there are forty people watching.' Miss Walters was actually talking about the problems of filming a love scene for a recent film, but what the waiter imagined as he staggered off to safety will never be known.

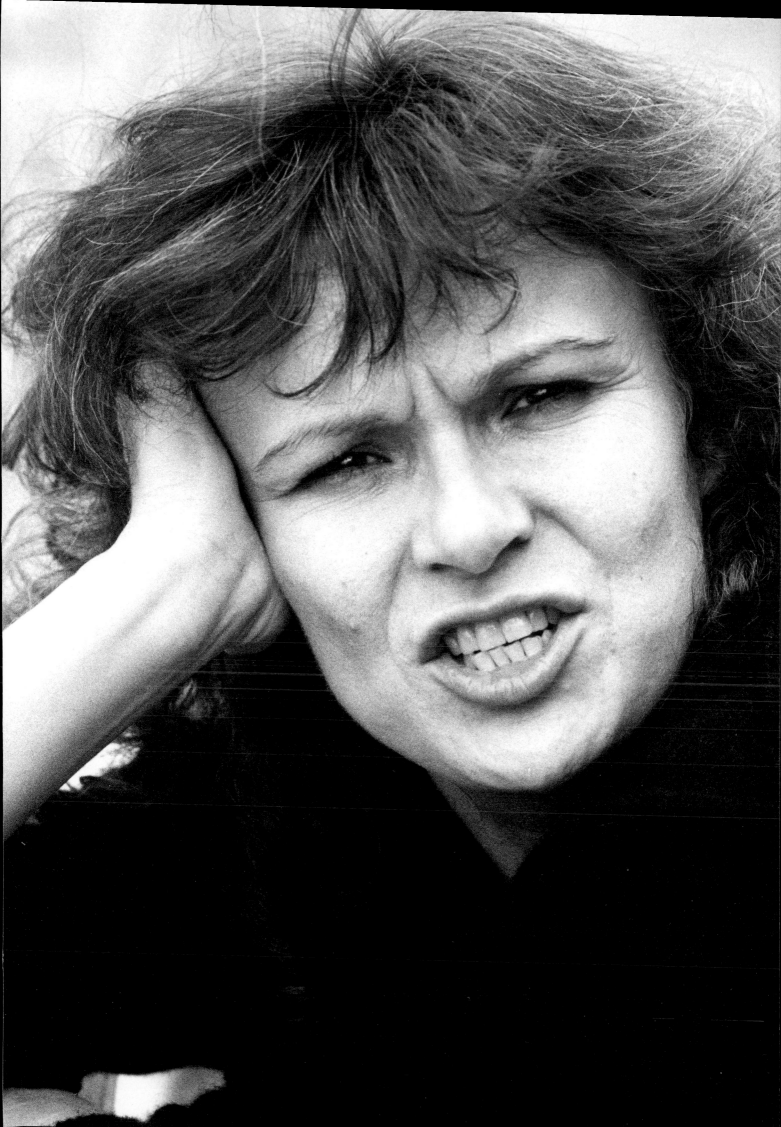

BILLY WILDER

The accent is Viennese/Brooklyn, at sixty-three he has the damaged-cherub looks born of a baby face to which thick frame glasses and bushy eyebrows have been added. The conversation can be wry going on abrasive. He has the reputation of being a cynic and his films like Sunset Boulevard, Some Like It Hot *and* The Apartment *give evidence to support the claim. He has also won six Oscars. Looking at the current state of his life, he said: 'Disengaged is the operative word. As you get older and slightly more affluent the temptation is to acquire more - three houses, a Ferrari, a yacht - and start running a studio. I don't. I'm not that greedy and I'm not that good.'*

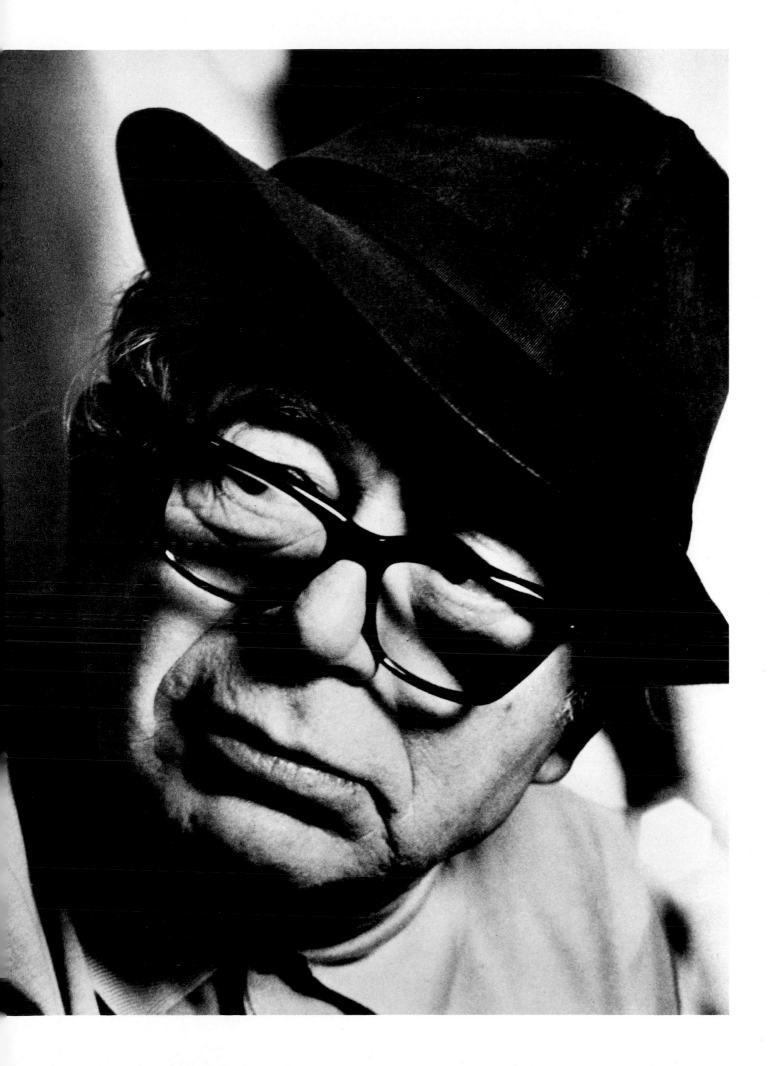

TENNESSEE WILLIAMS

The most worrying thing about Tennessee Williams was his chuckle, an obligato cackle which covered and obscured the end of almost every sentence and emphasized a point of humour which remained entirely private. But the man who coined the line 'I exist on the charity of strangers' for Blanche Dubois did reveal his own fixation with money, particularly when discussing his autobiography which spoke of his brushes with poverty and insanity. 'I only got a $50,000 advance. That really was a small advance. Someone should audit the publishers. They should be . . .' Cackle, cackle.

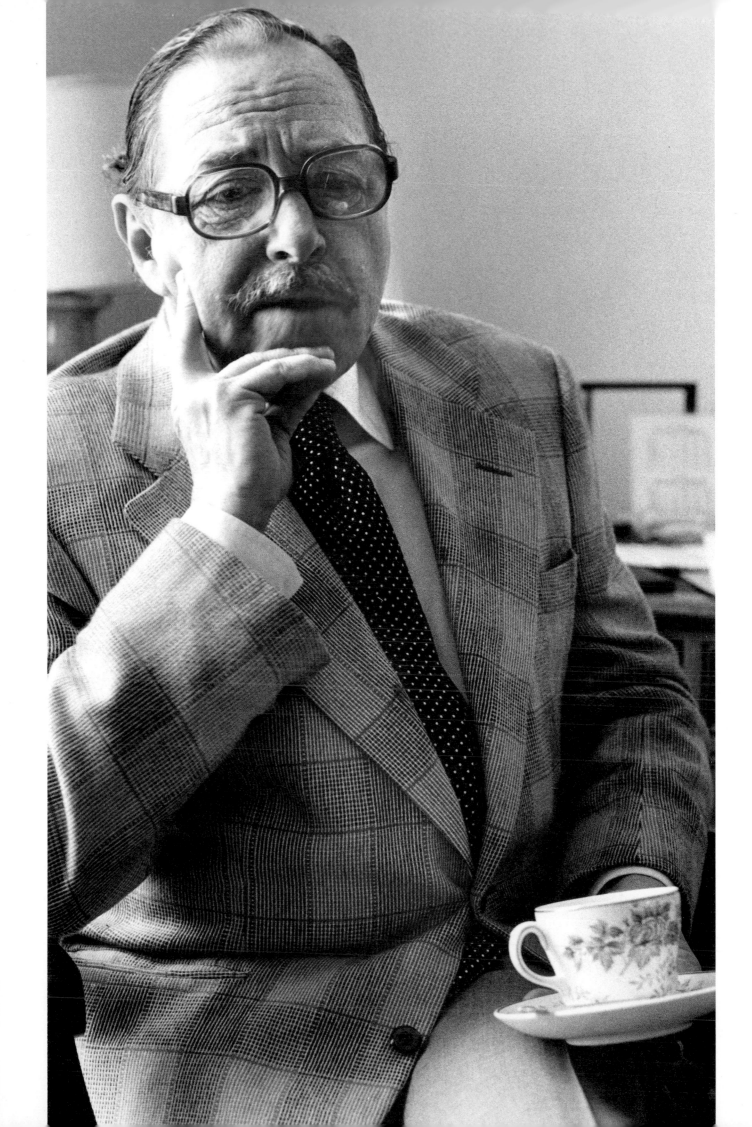

FRANCO ZEFFIRELLI

Franco Zeffirelli is a one-man walking Italian Renaissance travelling the theatres and opera houses of the world, befriending wherever he goes with a gift for conversation which ranges from scurrilous gossip to the deeply spiritual, and pausing occasionally to make a film. But it was a long time before he fell to the blandishments of Hollywood. 'Hollywood is dangerous for me. It is very pleasant, alive and beautiful, but it is a tight place. They do not let intruders get into the place easily. They might say they love your picture, but what they really love is the money success.'

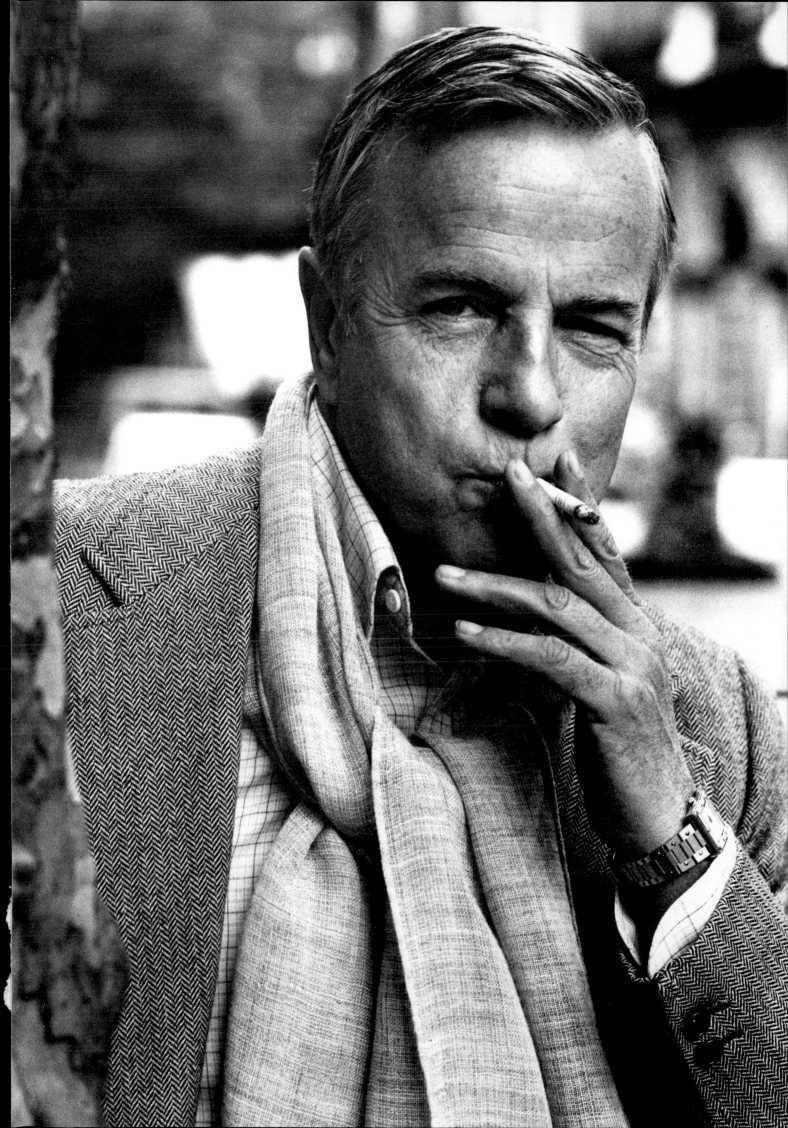